Letters from Father Christmas

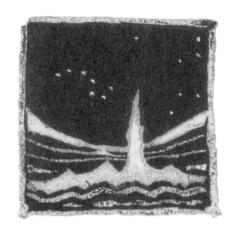

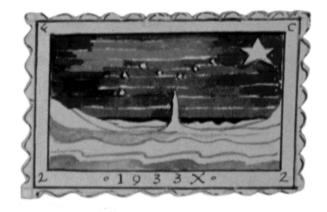

J.R.R. Tolkien Letters from Father Christmas

Edited by Baillie Tolkien

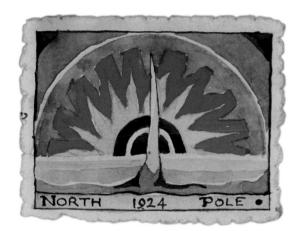

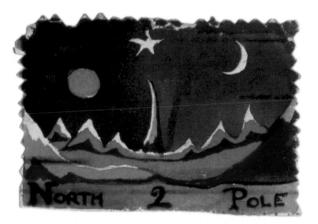

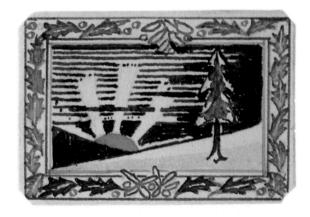

Houghton Mifflin Company

BOSTON . NEW YORK

This edition published by Houghton Mifflin Company 2004

First published by George Allen & Unwin 1976 Revised edition first published by HarperCollins*Publishers* 1999

This revised edition copyright © The J.R.R. Tolkien Copyright Trust 1999, 2004, except for previously unpublished material, which is copyright © The Tolkien Trust 1999, 2004

All illustrated material in this book reproduced courtesy of The Bodleian Library, University of Oxford and selected from their holdings labeled MS Tolkien Drawings 36–68; 83, pages 1–65; and 89, page 18

All rights reserved.

For information about permission to reproduce selections from this book, write to trade.permissions@hmhco.com or to Permissions,
Houghton Mifflin Harcourt Publishing Company,
3 Park Avenue, 19th Floor, New York, New York 10016.

Visit our Web site: www.hmhco.com.

Library of Congress Cataloging-in-Publication Data is available.

ISBN 978-0-618-51265-2

Printed and bound in Hong Kong by Printing Express

HC 109

Introduction

To the children of J. R. R. Tolkien, the interest and importance of Father Christmas extended beyond his filling of their stockings on Christmas Eve; for he wrote a letter to them every year, in which he described in words and pictures his house, his friends, and the events, hilarious or alarming, at the North Pole. The first of the letters came in 1920, when John, the eldest, was three years old; and for over twenty years, through the childhoods of the three other children, Michael, Christopher and Priscilla, they continued to arrive each Christmas. Sometimes the envelopes, dusted with snow and bearing Polar postage stamps, were found in the house on the morning after his visit; sometimes the postman brought them; and the letters that the children wrote themselves vanished from the fireplace when no one was about.

As time went on, Father Christmas' household became larger, and whereas at first little is heard of anyone else except the North Polar Bear, later on there appear Snow-elves, Red Gnomes, Snow-men, Cave-bears, and the Polar Bear's nephews, Paksu and Valkotukka, who came on a visit and never went away. But the Polar Bear remained Father Christmas' chief assistant, and the chief cause of the disasters that led to muddles and deficiencies in the Christmas stockings; and sometimes he wrote on the letters his comments in angular capitals.

Eventually Father Christmas took on as his secretary an Elf named Ilbereth, and in the later letters Elves play an important part in the defence of Father Christmas' house and store-cellars against attacks by Goblins.

In this book are presented numerous examples of Father Christmas' shaky handwriting, and almost all the pictures that he sent are here reproduced; also included is the alphabet that the Polar Bear devised from the Goblin drawings on the walls of the caves where he was lost, and the letter that he sent to the children written in it.

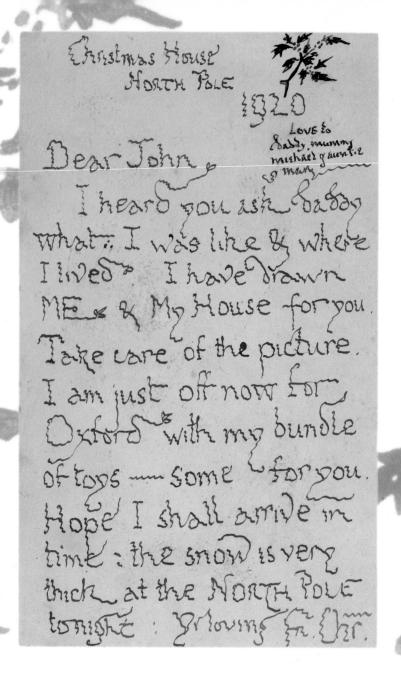

Christmas House, North Pole 22nd December 1920

Dear John

I heard you ask daddy what I was like and where I lived. I have drawn me and my house for you. Take care of the picture. I am just off now for Oxford with my bundle of toys – some for you. Hope I shall arrive in time: the snow is very thick at the North Pole tonight. Your loving Father Christmas

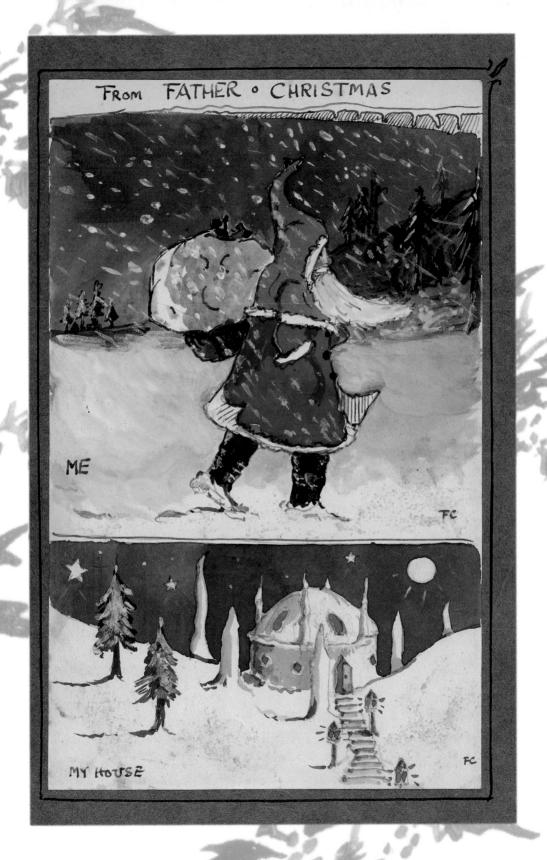

J's

7

North Pole Christmas Eve: 1923

My dear John,

It is very cold today and my hand is very shaky – I am nineteen hundred and twenty four, no! seven! years old on Christmas Day, – lots older than your great-grandfather, so I can't stop the pen wobbling, but I hear that you are getting so good at reading that I expect you will be able to read my letter

I send you lots of love (and lots for Michael too) and Lotts Bricks too (which are called that because there are lots more for you to have next year if you let me know in good time). I think they are prettier and stronger and tidier than Picabrix. So I hope you will like them.

Now I must go; it is a lovely fine night and I have got hundreds of miles to go before morning – there is such a lot to do.

A cold kiss from

Father Nicholas Christmas

THE

8

This was form and what to day and my hand is very inaky and fam nineteen hundred and twenty four years old on Christmas day of and stop the sear walsting, but I hear that you are fetting to stop the alle to read my letter yourself my letter

Sendresa lots of loveland lots for

It ideal too and Lotts Porietes lie

which are called that trecause there

are lots more for you to have noct year

if you let me know in good time so

It ink they are pretier and stronger

and tidier I than Picabrix is Inobe

you will like them chou and

it is a lovely dine night

and of have get hundreds of miles

to go before morning there is such

a let to do the orange of miles

to go before morning there is such

a let to do the orange of his of from

- Ar

W.

The Contract of the Contract o

Dear Michael Hilary

I am very busy this year: No time for letter. Lots of love. Hope the engine goes well. Take care of it. A big kiss.

with love from Father Christmas

December 23rd 1924

Dear John

Hope you have a happy Christmas. Only time for a short letter, my sleigh is waiting. Lots of new stockings to fill this year. Hope you will like station and things. A big kiss.

with love from Father Christmas

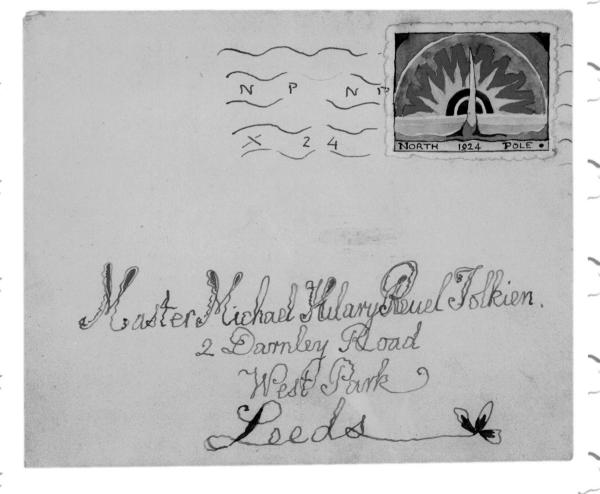

Cliff House, Top of the World, Near the North Pole Christmas 1925 1925

My dear boys,

I am dreadfully busy this year – it makes my hand more shaky than ever when I think of it – and not very rich; in fact awful things have been happening, and some of the presents have got spoilt, and I haven't got the North Polar bear to help me, and I have had to move house just before Christmas, so you can imagine what a state everything is in, and you will see why I have a new address, and why I can only write one letter between you both.

It all happened like this: one very windy day last November my hood blew off and went and stuck on the top of the North Pole.

I told him not to, but the North Polar Bear climbed up to the thin top to get it down – and he did. The pole broke in the middle and fell on the roof of my house, and the North Polar Bear fell through the hole it made into the dining room with my hood over his nose, and all the snow fell off the roof into the house and melted and put out all the fires and ran down into the cellars, where I was collecting this year's presents, and the North Polar Bear's leg got broken.

He is well again now, but I was so cross with him that he says he won't try to help me again – I expect his temper is hurt, and will be mended by next Christmas.

I send you a picture of the accident and of my new house on the cliffs above the North Pole (with beautiful cellars in the cliffs). If John can't read my old shaky writing (one thousand nine hundred and twenty-five years old) he must get his father to. When is Michael going to learn to read, and write his own letters to me? Lots of love to you both and Christopher, whose name is rather like mine.

That's all: Good Bye Father Christmas

P. S.

Father Christmas was in a great hurry - told me to put in one of his magic wishing crackers. As you pull, wish,

Khas Emas I am direct fully busy this year wit maked my hand more shaky than fuer of c when think of it and () not corrections in affact awful things have been happening, and some of the prestelents, have of got spoilt and I haven't get the North & Plan bear to help me and I have I had Expresse house just before Christman, so you can imagine what A 3 state Everything is in and you will see why I have a new address and why Granzonite one letter between you reall happened like this; one very windy day last eventser my had bles of and went and stuck on the lope of the North Case. The Shim not to but the S. S. Bear clian red up to the thirt too is not act to down — and he did. The pole south in the middle soul fell on the roof of my house and the SS. F. Bran fell through the hole it right into the dining own with my hard over his nose and all the snow fell of the roughing the house and melted and put out all the fires and ran hown into the sellars where of was collecting this year's presents, and the SV. 13 Brans Esq CP get broken J. Her is I well again now, but of was Sorress sith him that he saus he work on to help me again to present his temper is hurt, and will be mended sinust. This temper is hurt, and will be mended sinust. This temper is the assignet and of the series of the assignet and of the series of the assignet. my new house with stiffs above the M. C. Ewith seautiful cellans South the clift? If I want read my old shake untime fight of search of the winds get his father to when is Michael going to Exam to read, and in the his own letters to me also work love to your book and thrist owner; whose name is rather like mire. That's all: Good Bye & Falter Christmas

Me P.S. FR Christmas was in great hurry — told me to put in one of his magic wishing crackers. As you pull wish, & see + Fdoesn't come true, Excuse thick writing I have a fat paw. I help Fic C. with his packing: I live with him. I am the GREAT (Polar) BEAR

and see if it doesn't come true. Excuse thick writing I have a fat paw. I help Father Christmas with his packing: I live with him. I am the

GREAT (Polar) BEAR

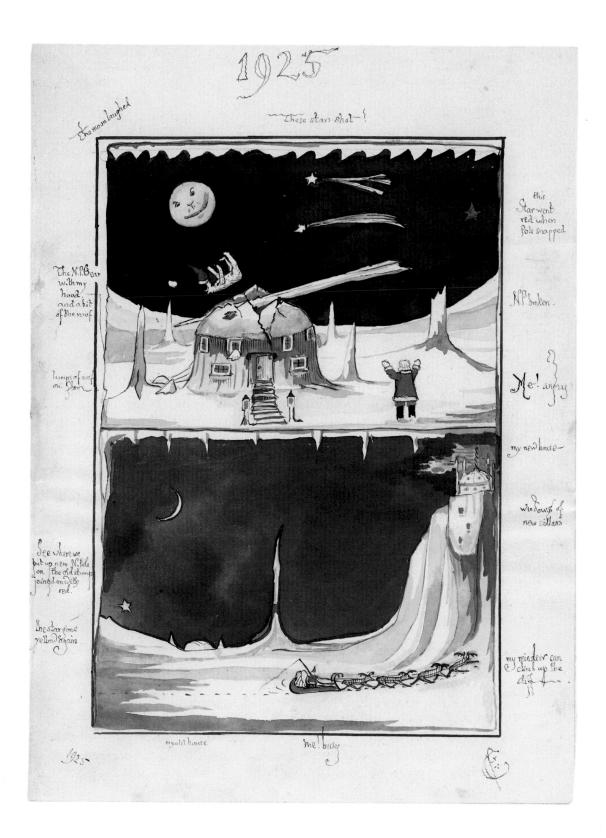

Cliff House, Top of the World, Near the North Pole Monday December 20th 1926

My dear boys,

I am more shaky than usual this year. The North Polar Bear's fault! It was the biggest bang in the world, and the most monstrous firework there ever has been. It turned the North Pole BLACK and shook all the stars out of place, broke the moon into four – and the Man in it fell into my back garden. He ate quite a lot of my Christmas chocolates before he said he felt better and climbed back to mend it and get the stars tidy.

Then I found out that the reindeer had broken loose. They were running all over the country, breaking reins and ropes and tossing presents up in the air. They were all packed up to start, you see – yes it only happened this morning: it was a sleighload of chocolate things, which I always send to England early. I hope yours are not badly damaged.

But isn't the North Polar Bear silly? And he isn't a bit sorry! Of course he did it – you remember I had to move last year because of him? The tap for turning on the Rory Bory Aylis fireworks is still in the cellar of my old house. The North Polar Bear knew he must never, never touch it. I only let it off on special days like Christmas. He says he thought it was cut off since we moved.

Anyway, he was nosing round the ruins this morning soon after breakfast (he hides things to eat there) and turned on all the Northern Lights for two years in one go. You have never heard or seen anything like it. I have tried to draw a picture of it; but I am too shaky to do it properly and you can't paint fizzing light can you?

I think the Polar Bear has spoilt the picture rather – of course he can't draw with those great fat paws –

Rude! I can - and write without shaking.

by going and putting a bit of his own about me chasing the reindeer and him laughing. He did laugh too. So did I when I saw him trying to draw reindeer, and inking his nice white paws.

Father Christmas had to hurry away and leave me to finish. He is old and gets worried when funny things happen. You would have laughed too! I think it is good of me laughing. It was a lovely firework. The reindeer will run quick to England this year. They are still frightened!...

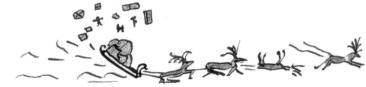

Tist of Jouse Toold Ehristmas 18126 Nearthe North Police Monday Dectigab 28th y dear boys, At was the bigg Cest Bears Hault! (Tithe most monstrous of firework of there turned the North Pole BLACK & Stars out of pisce broke the moon into Maninit fell into my backganden. he my Xmas choest-C-ales before he four and the a O climbed back to mend it and get the said the felt letter & found out that the reindeer had broken Esse There were Onin- Oning all over the country breaking reins and ropus I Otossing presents Out in the air The were Calipacked by yes it only happened this morning; it was a sleightend of chorostate things which of always send to End Wisnd early Chopse yours are not body damaged. C But ight the N.P.B sille Fond The isn't a bit C bony C! Of Course he did it - you c remember ? Chesar be deause of him? The tup for turing on had bomole last DATILIS Fireworks is still in the cellar, of my old Sporse The N. & B. Knewhe must never never touchit forty that it of on special days like Elvistmas. He says he hought it was suff since we moved - anyway The was noting round by ning office morning soon after breakfast The Prides things to eat Theory and troned on all the Monthem Lights for two years in Cone so You have never heard or seen anything the it. Thous Fried to draw in Chieture of it; but fam too shake it do it properly and you contraint Figging Ught zan you? Eting the PB has spent the picture ruther - Us course be can't draw with These great fat pais - by soing and putting a sit of he's signifation me chasing The Orender and him Sanghing The Ald laughto to did twhen & southing rude . MPB PTO I can - and write without shorting

Enging to draw reindeer, and inking his rice while power FATHER X. had to hurry away and leave me to finish. He isold and jets worried when funny things happen. You would have laughed too! I think it is good of me laughting. It was a lovely frework. The reindeer will run quick to England this year. They are still frightened! I must go and help pack. Idont know what F.C would do without me. He always forgets what a lot of packing Ido The Snow Man is addressing our cavelopes this year. He is F.C's gardener - but we don't get much but snowdrops and frost-forms to grow here. He always writes in white just with his finger. A merry Christmas to you from NPB Find to be from father Christmas

I must go and help pack. I don't know what Father Christmas would do without me. He always forgets what a lot of packing I do for him...

The Snow Man is addressing our envelopes this year. He is Father Christmas's gardener – but we don't get much but snowdrops and frost-ferns to grow here. He always writes in white, just with his finger...

A merry Christmas to you from North Polar Bear

And love from Father Christmas to you all.

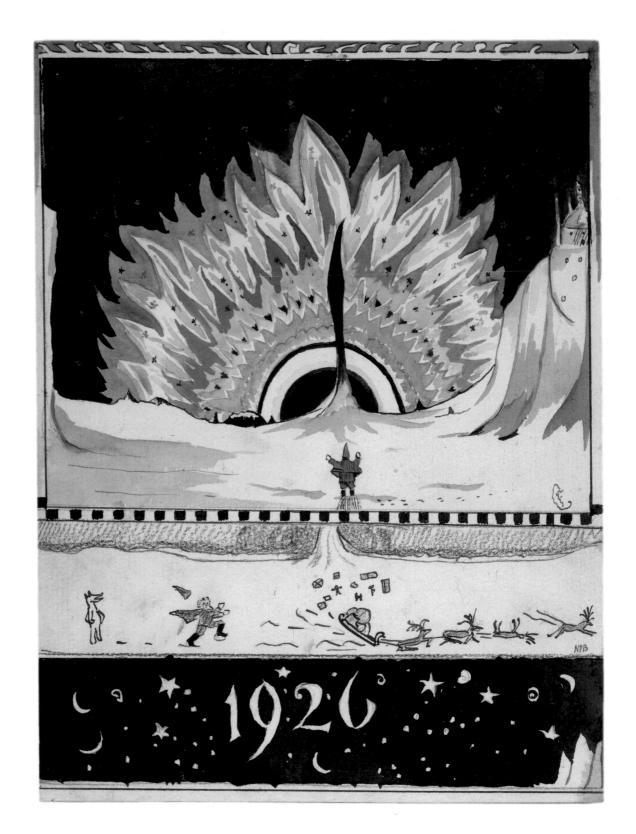

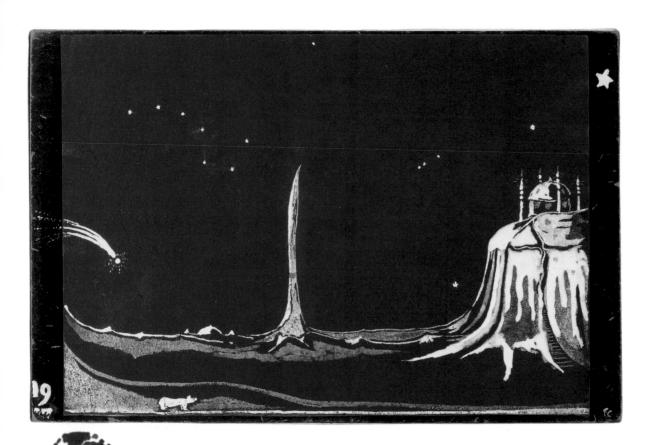

der people-:

Cliff House, Top o'the World, near the North Pole Wednesday December 21st 1927

My dear people: there seem to get more and more of you every year.

I get poorer and poorer: still I hope that I have managed to bring you all something you wanted, though not everything you asked for (Michael and Christopher! I haven't heard from John this year. I suppose he is growing too big and won't even hang up his stocking soon).

It has been so bitter at the North Pole lately that the North Polar Bear has spent most of the time asleep and has been less use than usual this Christmas.

Everybody does sleep most of the time here in winter – especially Father Christmas.

The North Pole became colder than any cold thing ever has been, and when the North Polar Bear put his nose against it – it took the skin off: now it is bandaged with red flannel. Why did he? I don't know, but he is always putting his nose where it oughtn't to be – into my cupboards for instance.

That's because I am hungry

Also it has been very dark here since winter began. We haven't seen the Sun, of course, for three months, but there are no Northern Lights this year – you remember the awful accident last year? There will be none again until the end of 1928. The North Polar Bear has got his cousin (and distant friend) the Great Bear to shine extra bright for us, and this week I have hired a comet to do my packing by, but it doesn't work as well.

The North Polar Bear has not really been any more sensible this year:

I have been perfectly sensible, and have learnt to write with a pen in my mouth instead of a paintbrush.

Yesterday he was snowballing the Snow Man in the garden and pushed him over the edge of the cliff so that he fell into my sleigh at the bottom and broke lots of things – one of them was himself. I used some of what was left of him to paint my white picture. We shall have to make ourselves a new gardener when we are less busy.

The Man in the Moon paid me a visit the other day – a fortnight ago exactly – he often does about this time, as he gets lonely in the Moon, and we make him a nice little Plum Pudding (he is so fond of things with plums in!)

His fingers were cold as usual, and the North Polar Bear made him play 'snapdragons' to warm them. Of course he burnt them, and then he licked them, and then he liked the brandy, and then the Bear gave him lots more, and he went fast asleep on the sofa. Then I went down into the cellars to make crackers, and he rolled off the sofa, and the wicked bear pushed him underneath and forgot all about him! He can never be away a whole night from the moon; but he was this time.

I have never been expected to look after the Man in the Moon before. I was very nice to him, and he was very comfy under the sofa.

Suddenly the Snow Man (he wasn't broken then) rushed in out of the garden, next day just after teatime, and said the moon was going out! The dragons had come out and were making an awful smoke and smother. We rolled him out and shook him and he simply whizzed back, but it was ages before he got things quite cleared up.

I believe he had to let loose one of his simply terrificalest freezing magics before he could drive the dragons back into their holes, and that is why it has got so cold down here.

The Polar Bear only laughs when I tell him it's his fault, and he curls up on my hearthrug and won't do anything but snore.

My messengers told me that you have somebody from Iceland staying with you. That is not so far from where I live, and nearly as cold. People don't hang up stockings there, and I usually pass by in a hurry, though I sometimes pop down and leave a thing or two for their very jolly Christmas Trees.

My usual way is down through Norway, Denmark, Germany, Switzerland, and then back through Germany, Northern France, Belgium, and so into England: and on the way home I pass over the sea, and sometimes Iceland and I can see the twinkling lights faint in the valleys under their mountains. But I go by quick, as my reindeer gallop as hard as they can there – they always say they are frightened a volcano or a geyser will go off underneath them.

This must be all: I have written you a very long letter this year as there was nothing to draw, but dark and snow and stars.

Love to you all, and happiness next year.

Your loving Father Christmas

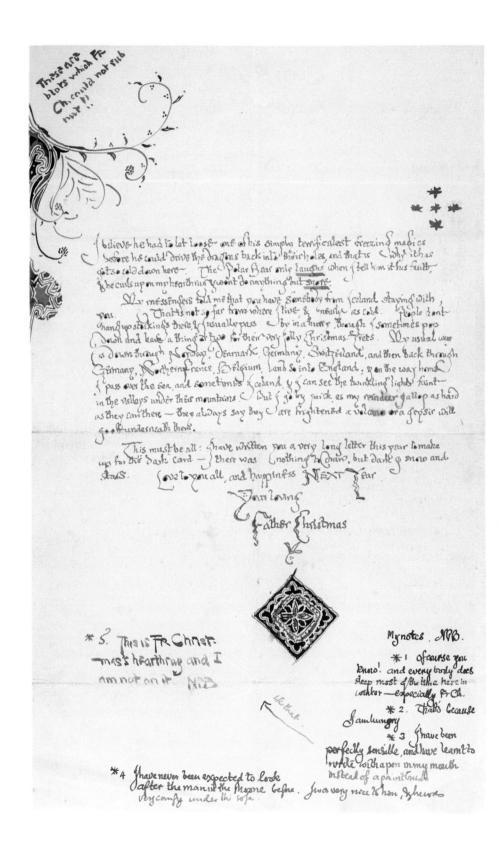

Top o' the World, North Pole Thursday December 20th 1928 My dear boys,

Another Christmas and I am another year older – and so are you. I feel quite well all the same – very nice of Michael to ask – and not quite so shaky. But that is because we have got all the lighting and heating right again after the cold dark year we had in 1927 – you remember about it?

And I expect you remember whose fault it was? What do you think the poor dear old bear has been and done this time? Nothing as bad as letting off all the lights. Only fell from top to bottom of the main stairs on Thursday!

Who'd left the soap on the stairs? Not me!

We were beginning to get the first lot of parcels down out of the storerooms into the hall. Polar Bear would insist on taking an enormous pile on his head as well as lots in his arms. Bang Rumble Clatter Crash! Awful moanings and growlings.

I ran out on to the landing and saw he had fallen from top to bottom on to his nose leaving a trail of balls, bundles, parcels and things all the way down – and he had fallen on top of some and smashed them. I hope you got none of these by accident? I have drawn you a picture of it all. Polar Bear was rather grumpy at my drawing it:

Of course, naturally.

He says my Christmas pictures always make fun of him and that one year he will send one drawn by himself of me being idiotic (but of course I never am, and he can't draw well enough).

Yes I can. I drew the flag at the end.

He joggled my arm and spoilt the little picture at the bottom of the moon laughing and Polar Bear shaking his fist at it.

When he had picked himself up he ran out of doors and wouldn't help clear up because I sat on the stairs and laughed as soon as I found there was not much damage done – that is why the moon smiled: but the part showing Polar Bear angry was cut off because he smudged it.

But anyway I thought you would like a picture of the inside of my new big house for a change. The chief hall is under the largest dome, where we pile the presents usually ready to load on the sleighs at the doors. Polar Bear and I built it nearly all ourselves, and laid all the blue and mauve tiles. The banisters and roof are not quite straight...

Not my fault. Father Christmas did the banisters.

...but it doesn't really matter. I painted the pictures on the walls of the trees and stars and suns and moons. Then I said to Polar Bear, "I shall leave the frieze (F. R. I. E. Z. E.) to you."

He said, "I should have thought there was enough freeze outside – and your colours inside, all purply-grey-y-bluey-pale greeny are cold enough too."

Well, my dears, I hope you will like the things I am bringing: nearly all you asked for and lots of other little things you didn't, and which I thought of at the last minute. I hope you will share the railway things and farm and animals often, and not think they are absolutely only for the one whose stocking they were in. Take care of them, for they are some of my very best things.

Love to Chris: love to Michael: love to John who must be getting very big as he doesn't write to me any more (so I simply had to guess paints – I hope they were all right: Polar Bear chose them; he says he knows what John likes because John likes bears).

Your loving Father Christmas

Cop o' the World"

NORTH POLE

Thursday December 20th

1928

MOTHER EMRISTMAS and I am another year older—and so are you. I feel guite well all the same - Jety nice of MICHAEL to ask—and not quite so shake. But that is be cause we have but all the lighting and heat fing night again after the cold dark year we had in 1927 - you remember about it? and I expect you remember whose fault it was? What do you think the poor dear old bear has been and done this time? Nothing as bad as letting off all the lights. Only tell from top to bottom of the main stairs on Thursday! We were beginning to get the first lot of parcels down out of the storerooms into the hall. P. Bosuld in Isist on taking an enormous pile on his head as well as lots in his arms. Bang Rumble Chatter Crash! awful meanings and grawlings: I ran out on to the landing and said he had fallen from top to bottom onto his nost-leaving a trail of balls bundles parcels & things all the way down - and he had Fallen on top of Some and smashed them. I hope you got none of these by accident? That drawn pour a picture of it all. Of was rather frumpy atmy drawing it : he sais my Christmas pictures always make fun offim I that one year he will send one drawn by himself of me being idiotic (but of course I never am, and he can't draw well enough). The oxiled my arm and spoilt the little picture at the bottom, of the moon

WHOO LEFT THE SOAP ON THE STANES? NOT THE

OF COURSE WATURALY

YESICAN IDREW FLAG AT END.

Boxing Day, 1928

I am frightfully sorry – I gave this to the Polar Bear to post and he forgot all about it! We found it on the hall table – today.

But you must forgive him: he has worked very hard for me and is dreadfully tired. We have had a busy Christmas. Very windy here. It blew several sleighs over before they could start.

Love again, Father Christmas

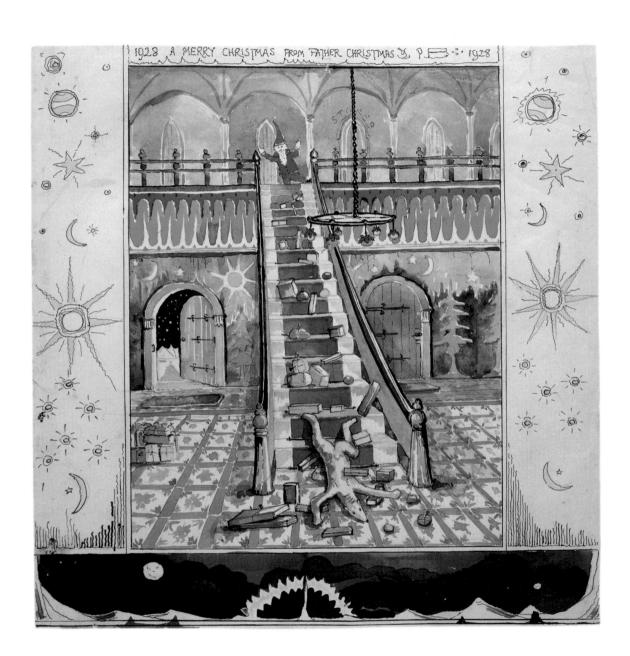

. 1929

November 1929

Dear boys,

My paw is better. I was cutting Christmas trees when I hurt it. Don't you think my writing is much better too? Father Christmas is very bisy already. So am I. We have had hevy snow and sum of our messengers got buerried and sum lost: that is whi you have not herd lately.

Love to John for his birthday. Father Christmas says my English spelling is not good. I kant help it. We don't speak English here, only Arktik (which you don't know. We also make our letters different – I have made mine like Arktik letters for you to see. We always rite \(^1\) for T and V for U. This is sum Arktik langwidge wich means "Goodby till I see you next and I hope it will bee soon." – Mára mesta an ni véla tye ento, ya rato nea.

P. B.

My real name is Karhu but I don't tell most peeple.

P.S. I like letters and think Cristofers are nice

PS WIKE LEMERS AND THINK LRISTOFERS AR NICE.

MY PAW IS BETTER I WAS CUTTING CHRISTMAS
PREES WEN I HURT IT. DOONT YOU THINK MY WRITING
IS MUCH BETTER 1000? FATHER X IS VERY BISY
ALREADY. SO AM I WE HAVE HAD HEVY SNOW AND
SUM OF OUR MESSENGERS GOT BUERRIED AND SUM
LOST: THAT IS WHI YOU HAVE NOT HERD LATELY.
LOVE TO JOHN FOR HIS BIRTHDAY FATHER X SAYS
MI ENGLISH SPELLING IS NOT GOOD. I KANT HELP IT. WE
DON'T SPEAK ENGLISH HERE, ONLY ARKTIK (WHICH YOU

DEAR BOYS

DONA KNOW. WE AUSO MAKE OUR LEADERS DIFFERENT

I HAVE MADE MINE LIKE ARKAIK LEADERS FOR YOU TO

SEE WE ALWAYS RIDE A FOR T AND V FOR U.

THIS IS SVM ARKAIK LANGWIDGE WICH MEANS

"GOOD BY AILL ISEE YOU NEXT AND I HOPE IT

WILL BEE SOON "MARA MESTA AN NI VELA AYE

ENTO, YA RAAD NEA

P. B.

MY REAL NAME IS KARHU BUT I DON'T DELL

MOST PEEPLE.

MI PAW

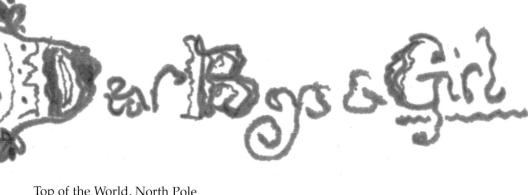

Top of the World, North Pole Xmas 1929

Dear Boys and Girl

It is a light Christmas again, I am glad to say – the Northern Lights have been specially good. There is a lot to tell you. You have heard that the Great Polar Bear chopped his paw when he was cutting Christmas Trees. His right one – I mean not his left; of course it was wrong to cut it, and a pity too for he spent a lot of the Summer learning to write better so as to help me with my winter letters.

We had a Bonfire this year (to please the Polar Bear) to celebrate the coming in of winter. The Snow-elves let off all the rockets together, which surprised us both. I have tried to draw you a picture of it, but really there were hundreds of rockets. You can't see the elves at all against the snow background.

The Bonfire made a hole in the ice and woke up the Great Seal, who happened to be underneath. The Polar Bear let off 20,000 silver sparklers afterwards – used up all my stock, so that is why I had none to send you. Then he went for a holiday!!! – to north Norway, and stayed with a wood-cutter called Olaf, and came back with paw all bandaged just at the beginning of our busy times.

There seem more children than ever in England, Norway, Denmark, Sweden, and Germany, which are the countries I specially look after (and of course North America and Canada) – not to speak of getting stuff down to the South Pole for children who expect to be looked after though they have gone to live in New Zealand or Australia or South Africa or China.

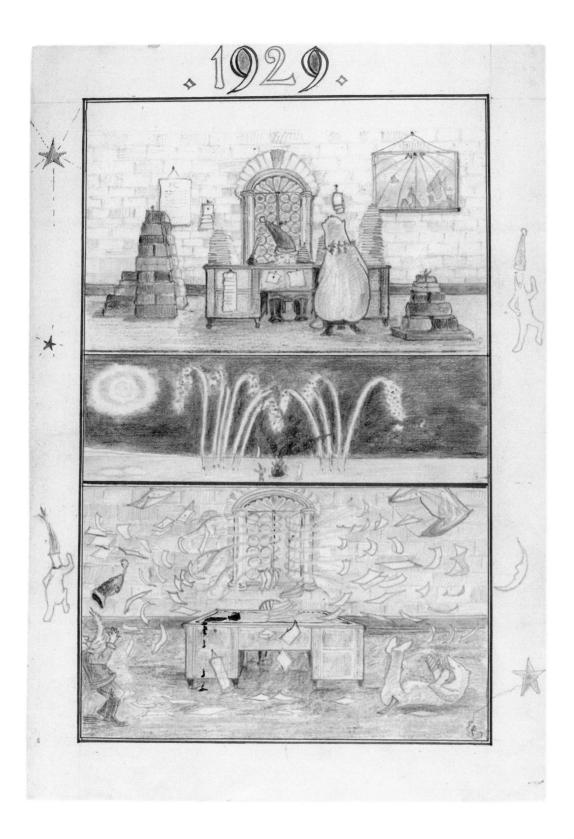

It is a good thing clocks don't tell the same time all over the world or I should never get round, although when my magic is strongest – at Christmas – I can do about a thousand stockings a minute, if I have it all planned out beforehand. You could hardly guess the enormous piles of lists I make out. I seldom get them mixed.

But I am rather worried this year. In my office and packing-room, the Polar Bear reads out names while I copy them down. We had awful gales here, worse than you did, tearing clouds of snow to a million tatters, screaming like demons, burying my house almost up to the roofs. Just at the worst, the Polar Bear said it was stuffy! and opened a north window before I could stop him. You can guess the result – the North Polar Bear was buried in papers and lists; but that did not stop him laughing.

Also all my red and green ink was upset, as well as black, – so I am writing in chalk and pencil. I have some black ink left, and the Polar Bear is using it to address parcels.

I liked all your letters – very much indeed my dears. Nobody, or very few, write so much or so nicely to me. I'm specially pleased with Christopher's card, and his letters, and with his

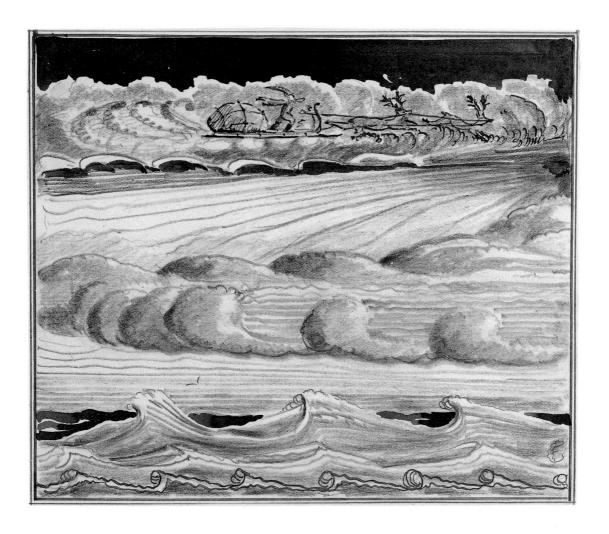

learning to write, so I am sending him a fountain pen and also a special picture for himself. It shows me crossing the sea on the upper North wind, while a South West gale – reindeer hate it – is raising big waves below.

This must be all now. I send you all my love. One more stocking to fill this year! I hope you will like your new house and the things I bring you.

Your Old Father Christmas

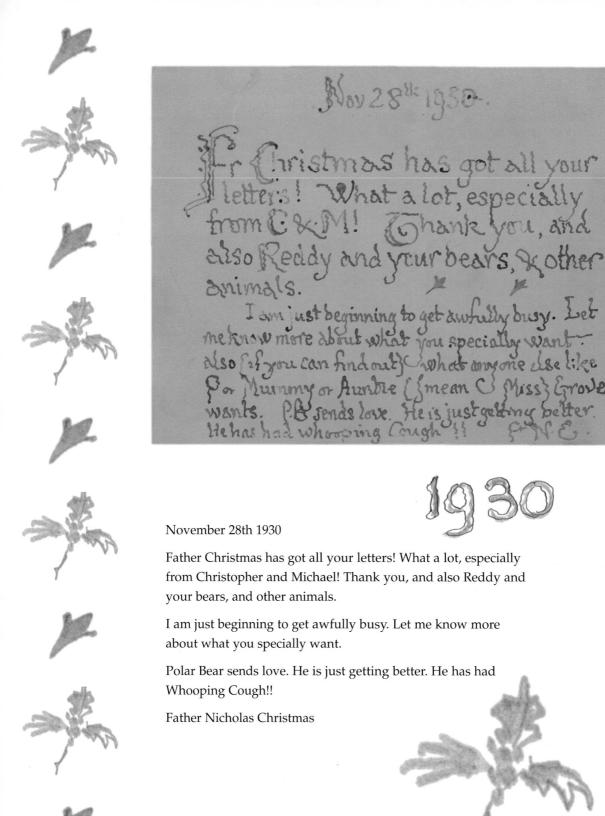

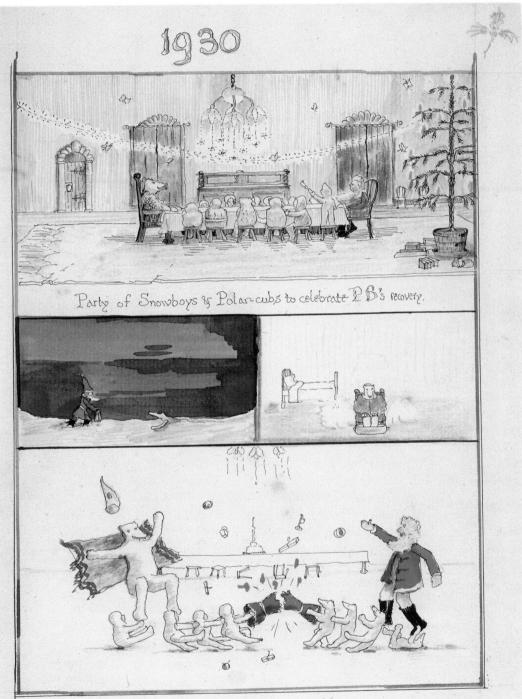

P.B recovers!

Christmas 1930

Not finished until Christmas Eve, 24th December

My dears,

I have enjoyed all your letters. I am dreadfully sorry there has been no time to answer them, and even now I have not time to finish my picture for you properly or to send you a full long letter like I mean to.

I hope you will like your stockings this year: I tried to find what you asked for, but the stores have been in rather a muddle – you see the Polar Bear has been ill. He had whooping cough first of all. I could not let him help with the packing and sorting which begins in November - because it would be simply awful if any of my children caught Polar whooping cough and barked like bears on Boxing Day. So I had to do everything myself in the preparations.

Of course, Polar Bear has done his best - he cleaned up and mended my sleigh, and looked after the reindeer while I was busy. That is how the really bad accident happened. Early this month we had a most awful snowstorm (nearly six feet of snow) followed by an awful fog. The poor Polar Bear went out to the reindeer-stables, and got lost and nearly buried: I did not miss him or go to look for him for a long while. His chest had not got well from whooping cough so this made him frightfully ill, and he was in bed until three days ago. Everything has gone wrong, and there has been no one to look after my messengers properly.

Aren't you glad the Polar Bear is better? We had a party of Snowboys (sons of the Snowmen, which are the only sort of people that live near – not of course men made of snow, though my gardener who is the oldest of all the snowmen sometimes draws a picture of a made Snowman instead of writing his name) and Polar Cubs (the Polar Bear's nephews) on Saturday as soon as he felt well enough.

He didn't eat much tea, but when the big cracker went off after, he threw away his rug, and leaped in the air and has been well ever since.

I've drawn you pictures of everything that happened – Polar Bear telling a story after all the tea things had been cleared away; me finding Polar Bear in the snow, and Polar Bear sitting with his feet in hot mustard and water to stop him shivering. It didn't – and he sneezed so terribly he blew five candles out.

Still he is all right now – I know because he has been at his tricks again: quarrelling with the Snowman (my gardener) and pushing him through the roof of his snow house; and packing lumps of ice instead of presents in naughty children's parcels. That might be a good idea, only he never told me and some of them (with ice) were put in warm storerooms and melted all over good children's presents!

Well my dears there is lots more I should like to say – about my green brother and my father, old Grandfather Yule, and why we were both called Nicholas after the Saint (whose day is December sixth) who used to give secret presents, sometimes throwing purses of money through the window. But I must hurry away – I am late already and I am afraid you may not get this in time.

Kisses to you all,

Father Nicholas Christmas

P.S. (Chris has no need to be frightened of me).

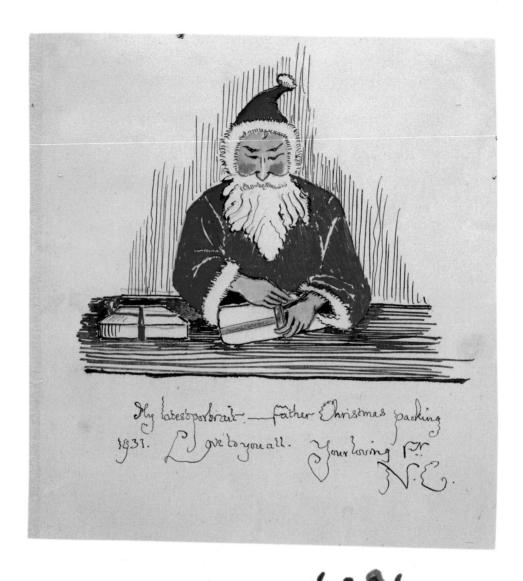

Cliff House October 31st 1931

Dear Children,

Already I have got some letters from you! You are getting busy early. I have not begun to think about Christmas yet. It has been very warm in the North this year, and there has been very little snow so far. We are just getting in our Christmas firewood.

This is just to say my messengers will be coming round regularly now Winter has begun – we shall be having a bonfire

has beour - De shall be Sonfire tomorrow like to hear from you: under & Wednesday evenings are the Dest times to post to never know what he when the Xmas rush begins. Send my love to John. WLAD FRX HAS WAKT UP. HESLEPT NEARLY ALL THIS HOT SUMMER. I WISH WE KOOD HAVE 4 NOW. MY LOAT 14 DVINE YELLOW. LOVE. PIS

tomorrow – and I shall like to hear from you: Sunday and Wednesday evenings are the best times to post to me.

The Polar Bear is quite well and fairly good – (though you never know what he will do when the Christmas rush begins.) Send my love to John.

Your loving Father Nicholas Christmas

Glad Father Christmas has wakt up. He slept nearly all this hot summer. I wish we kood have snow. My coat is quite yellow.

Love Polar Bear

Cliff House, North Pole December 23rd 1931

My dear Children

I hope you will like the little things I have sent you. You seem to be most interested in Railways just now, so I am sending you mostly things of that sort. I send as much love as ever, in fact more. We have both, the old Polar Bear and I, enjoyed having so many nice letters from you and your pets. If you think we have not read them you are wrong; but if you find that not many of the things you asked for have come, and not perhaps quite as many as sometimes, remember that this Christmas all over the world there are a terrible number of poor and starving people.

I (and also my Green Brother) have had to do some collecting of food and clothes, and toys too, for the children whose fathers and mothers and friends cannot give them anything, sometimes not even dinner. I know yours won't forget you.

So, my dears, I hope you will be happy this Christmas and not quarrel, and will have some good games with your Railway all together. Don't forget old Father Christmas, when you light your tree.

Nor me!

It has gone on being warm up here as I told you – not what you would call warm, but warm for the North Pole, with very little snow. The North Polar Bear, if you know who I mean, has been lazy and sleepy as a result, and very slow over packing, or any job except eating. He has enjoyed sampling and tasting the food parcels this year (to see if they were fresh and good, he said).

Somebody haz to - and I found stones in some of the kurrants.

But that is not the worst – I should hardly feel it was Christmas if he didn't do something ridiculous. You will never guess what he did this time! I sent him down into one of my cellars – the Cracker-hole we call it – where I keep thousands of boxes of crackers (you would like to see them, rows upon rows, all with their lids off to show the kinds of colours).

Well, I wanted 20 boxes, and was busy sorting soldiers and farm things, so I sent him; and he was so lazy he took two Snowboys (who aren't allowed down there) to help him. They started pulling crackers out of boxes, and he tried to box them (the boys' ears I mean), and they dodged and he fell over, and let his candle fall right POOF! into my firework crackers and boxes of sparklers.

I could hear the noise, and smell the smell in the hall; and when I rushed down I saw nothing but smoke and fizzing stars, and old Polar Bear was rolling over on the floor with sparks sizzling in his coat: he has quite a bare patch burnt on his back.

Chiff House North Jelle December 23rd 1931

dear Inldren son 9:9:9:9

Thou seem to The most interested in Railway of have sent you.

If on seem to The most interested in Railway of sont now so as ever in Plact more We have both the std Plan and Jenjoyed nawing somany nice latters from you and your yets. If for think we have not read them you are wrong just if you find that not many of the trings you asked for have come is not perhaps quite as many as sometimes remember that this Prist I mad old over the sworld there are a terrible number of part & staming people. If & also my tireen prother have had to do some the ching of jour of the dridgen whose sathers & mothers and riends carnot give a ligem anathing sometimes not even dinner. I know yours with forget you do my dears, I have you will be hard this strong all trust forget you do my dears, I have you will be hard this strong all trust forget you do not growed a games with your fails and the some beat your forget you do not growed a games with your fails and the some beat here. I will have some good I games with your fails and the some beat the trust for the forget you for first mas when you light your beet together. I won't forget sld fail for first mas when you light your beet

The would call warm, "but wa/m for the warm with call warm, "but wa/m for the warm with the snow. The N.P.B. if you know who of mean has been lay a sleepy as a result of very slow over packing or any jdo except eating—he has enjoyed sampling and tasting the food parcels, this capt lace the see if they were fresh a good, he said But that is not the worst—of should harding feel it was thristmas if he dadnt do something ridaculous. You will never quest what he did this time! I sent him do whim one of my cellars—the tracker hole we tall it where I keep thousands of boxes of crackers (gas would like to see them, rows idpon rows all with them has off to show the kinds & tolours)—well, I wanted 20 boxes a was busy sorring soldiers of farm things,

F SOMEBODY HAZ TO -AND I FOUND STONES IN SOME OF THE KURRANTS

43

NOR ME.N. PB!

It looked fine!

That's where Father Christmas spilled the gravy on my back at dinner!

The Snowboys roared with laughter and then ran away. They said it was a splendid sight – but they won't come to my party on St Stephen's Day; they have had more than their share already.

Two of the Polar Bear's nephews have been staying here for some time – Paksu and Valkotukka ('fat' and 'white-hair' they say it means). They are fat-tummied polar-cubs, and are very funny boxing one another and rolling about. But another time, I shall have them on Boxing Day, and not just at packing-time. I fell over them fourteen times a day last week.

And Valkotukka swallowed a ball of red string, thinking it was cake, and he got it all wound up inside and had a tangled cough – he couldn't sleep at night, but I thought it rather served him right for putting holly in my bed.

It was the same cub that poured all the black ink yesterday into the fire – to make night: it did and a very smelly smoky one. We lost Paksu all last Wednesday and found him on Thursday morning asleep in a cupboard in the kitchen; he had eaten two whole puddings raw. They seem to be growing up just like their uncle.

Not fair!

Goodbye now. I shall soon be off on my travels once more. You need not believe any pictures you see of me in aeroplanes or motors. I cannot drive one, and don't want to; and they are too slow anyway (not to mention smell). They cannot compare with my own reindeer, which I train myself. They are all very well this year, and I expect my posts will be in very good time. I have got some new young ones this Christmas from Lapland (a great place for wizards; but these are WHIZZERS).

Bad!

One day I will send you a picture of my deer-stables and harness-houses. I am expecting that John, although he is now over 14, will hang up his stocking this last time; but I don't forget people even when they are past stocking-age, not until they forget me. So I send LOVE to you ALL, and especially little PM, who is beginning her stocking-days and I hope they will be happy.

Your loving Father Christmas

P.S. This is all drawn by North Polar Bear. Don't you think he is getting better? But the green ink is mine – and he didn't ask for it.

THAT'S WHIKE ELSPILLED THEGRAVY ON MYBACK ATDINNER'

So I sent him; and he was so lagy he took two Snow-boys (who arent ollowed down there) to help him. They started pulling crackers out of boxes, and he bried to box them (the box's ears of mean), and they dodged and he fell over & let his candle fall higher poof into my fire work crackers of toxes of sparklers. I could hear the runse, I small the small in dre hall; I when I rushed down I saw risthing but smake and fizzing Store I old PAS was rolling over on the floor with sparks sizzling in his coat the has quite a bare parch sunt on his back. The Snow boys roared with laughter & Stren ran away. They said it was a splended sight but they won't come so my party on St Stephen's Day; they have had more than their share al ready

IT LOOKED FINE

Two of the PB's nephews have been staying There for some time I paksu and Vatkotukka ("fat" and white hair they say it means) They are fat-turmied plar-cubs, & no very furthe beging one another I rolling about. But another time & shall have them on Boxing-lay Chot just at exacking-time. I fell over them fourteen times a Clary East week. And Valkstukka swallowed a ball of red string the King it was take, and he got it all wound up viside and had a tangled cough I be couldn't sleep at right, but I thought it rather Served him non for putting holly in my bed. It was the same cub that pour ed all the stack inte resterday into the fire to make night it did a frame smally smoky one. I We Plost Paksu all last V Rednesday & found him on Thursday morning asleep in a supboard in she kitchen; he's had laten hero whose puds - mes raw. They seem to be growing up just like their uncle

Too one now & shall soon be off on my travels once more . You need not the Chave any pictures you seed me in aproplanes or motors. Commot drive one & Cornt Want to; and the Jare too slow anywar God to mention smell), they cannot compare with Iny own reinder which I train myself. They are all ving I well this yearly Jexpect my posts will be in Viry good time. I have got some new young ones this Christ. mas from Clapland (a great Slace For wifetds that these are WHIZZERS)

One day of will send you a pacture of my deer stables and harness houses. am expecting that John although heis now over 14, will have up his stocking this last time; but I don't forget people even when they are past stacking. age, not until drey forget me. So grand LOVE toyme CALL & especie sally little PMG, whois organing her stocking days & I hope they will be Thour Loving Father

on Summed and Summed on S.

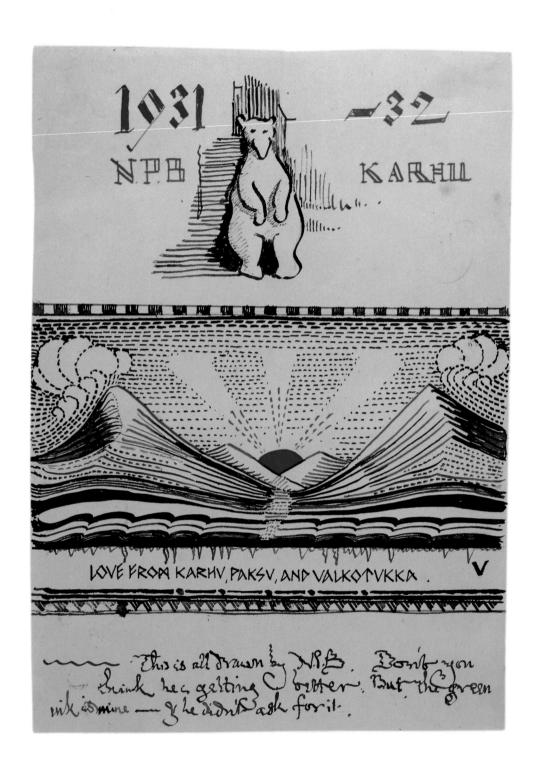

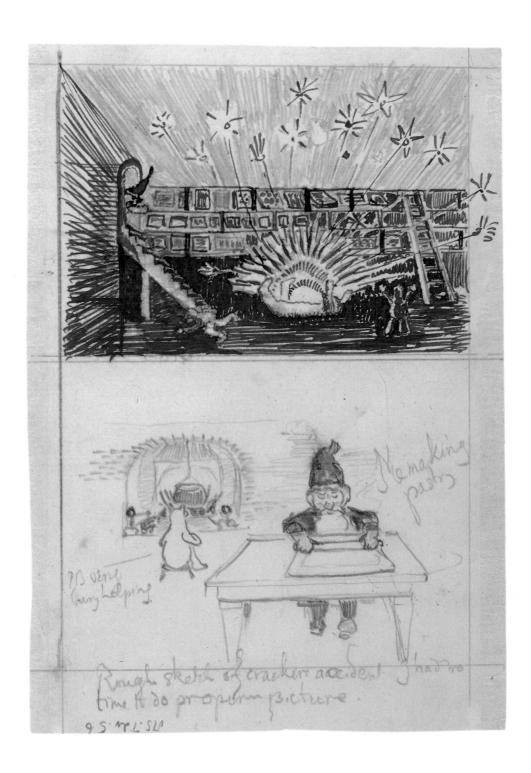

Cliff House, North Pole. November 30th 1932

1932

My dear children

Thank you for your nice letters. I have not forgotten you. I am very late this year and very worried – a very funny thing has happened. The Polar Bear has disappeared, and I don't know where he is. I have not seen him since the beginning of this month, and I am getting anxious. Tomorrow December, the Christmas month, begins, and I don't know what I shall do without him.

I am glad you are all well and your many pets. The Snowbabies holidays begin tomorrow. I wish Polar Bear was here to look after them. Love to Michael, Christopher and Priscilla. Please send John my love when you write to him.

Father N. Christmas.

Movember 30th.

Thank you for your nice letters. I have not forgotten you. I am very late this year & very worried—avery funny thing has happened. The J. B. has disappeared, & I don't know where he is I have not seen him since the beginning of this month, & I am getting anxious. Jomorrow Dee-ember the Christmas month, begins, & I don't know what I shall do without him.

pets. The snow balies holidays began tomorrow.
I wish PE was here to look after them. Torre
to M. C. & P. Please send J. my love when you
write to him.
Lasher & Christmas.

Cliff House, near the North Pole December 23rd 1932

My dear children,

There is a lot to tell you. First of all a Merry Christmas! But there have been lots of adventures you will want to hear about. It all began with the funny noises underground which started in the summer and got worse and worse. I was afraid an earthquake might happen. The North Polar Bear says he suspected what was wrong from the beginning. I only wish he had said something to me; and anyway it can't be quite true, as he was fast asleep when it began, and did not wake up till about Michael's birthday.

However, he went off for a walk one day, at the end of November I think, and never came back! About a fortnight ago I began to be really worried, for after all the dear old thing is really a lot of help, in spite of accidents, and very amusing.

One Friday evening (December 9th) there was a bumping at the front door, and a snuffling. I thought he had come back, and lost his key (as often before); but when I opened the door there was another very old bear there, a very fat and funny-shaped one. Actually it was the eldest of the few remaining cave-bears, old Mr Cave Bear himself (I had not seen him for centuries).

"Do you want your North Polar Bear?" he said. "If you do you had better come and get him!" It turned out he was lost in the caves (belonging to Mr Cave Bear, or so he says) not far from the ruins of my old house. He says he found a hole in the side of a hill and went inside because it was snowing. He slipped down a long slope, and lots of rock fell after him, and he found he could not climb up or get out again.

But almost at once he smelt goblin! and became interested, and started to explore. Not very wise; for of course goblins can't hurt him, but their caves are very dangerous.

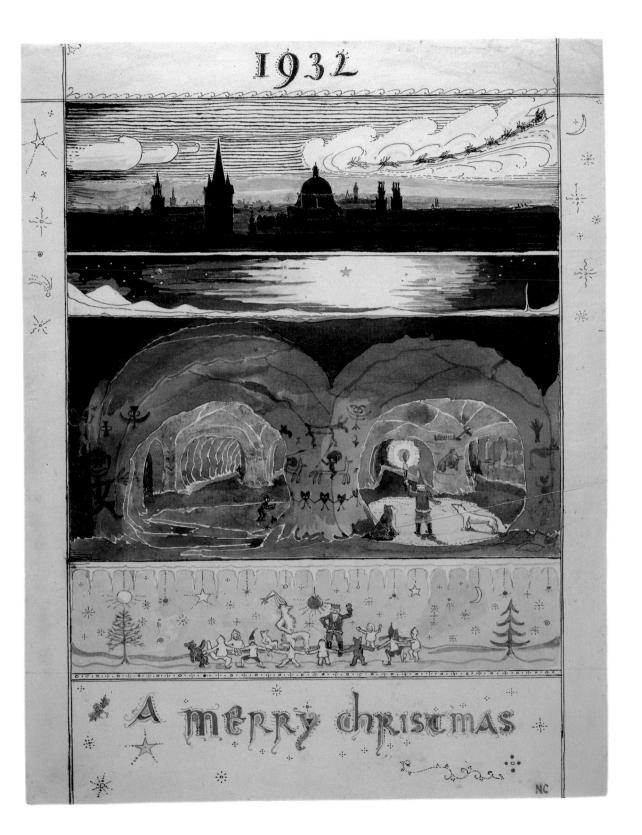

Naturally he soon got quite lost, and the goblins shut off all their lights, and made queer noises and false echoes.

Goblins are to us very much what rats are to you, only worse because they are very clever; and only better because there are, in these parts, very few. We thought there were none left. Long ago we had great trouble with them – that was about 1453 I believe – but we got the help of the Gnomes, who are their greatest enemies, and cleared them out.

Anyway, there was poor old Polar Bear lost in the dark all among them, and all alone until he met Mr Cave Bear (who lives there). Cave Bear can see pretty well in the dark, and he offered to take Polar Bear to his private back-door.

So they set off together, but the goblins were very excited and angry (Polar Bear had boxed one or two flat that came and poked him in the dark, and had said some very nasty things to them all); and they enticed him away by imitating Cave Bear's voice, which of course they know very well. So Polar Bear got into a frightful dark part, all full of different passages, and he lost Cave Bear, and Cave Bear lost him.

"Light is what we need." said Cave Bear to me. So I got some of my special sparkling torches – which I sometimes use in my deepest cellars – and we set off that night.

The caves are wonderful. I knew they were there, but not how many or how big they were. Of course the goblins went off into the deepest holes and corners, and we soon found Polar Bear. He was getting quite long and thin with hunger, as he had been in the caves about a fortnight. He said, "I should soon have been able to squeeze through a goblin-crack."

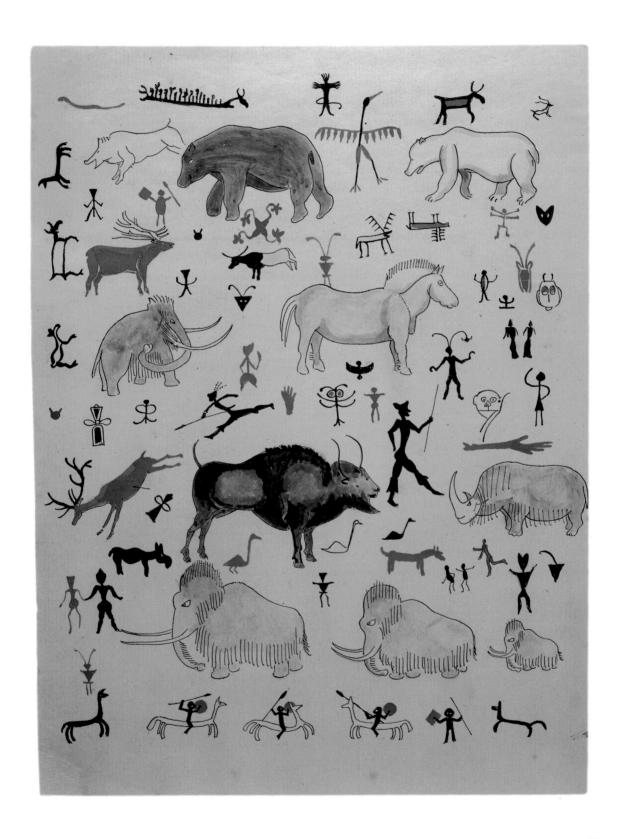

Polar Bear himself was astonished when I brought light; for the most remarkable thing is that the walls of these caves are all covered with pictures, cut into the rock or painted on in red and brown and black.

Some of them are very good (mostly of animals), and some are queer and some bad; and there are many strange marks, signs and scribbles, some of which have a nasty look, and I am sure have something to do with black magic.

Cave Bear says these caves belong to him, and have belonged to him or his family since the days of his great-great

Then Men came along – imagine it! Cave Bear says there were lots about at one time, long ago, when the North Pole was somewhere else. (That was long before my time, and I have never heard old Grandfather Yule mention it even, so I don't know if he is talking nonsense or not).

Many of the pictures were done by these cave-men – the best ones, especially the big ones (almost life-size) of animals, some of which have since disappeared: there are dragons and quite a lot of mammoths. Men also put some of the black marks and pictures there; but the goblins have scribbled all over the place. They can't draw well and anyway they like nasty queer shapes best.

North Polar Bear got quite excited when he saw all these things. He said: "These cave-people could draw better than you, Daddy Noel; and wouldn't your young friends just like to see some really good pictures (especially some properly drawn bears) for a change!"

Rather rude, I thought, if only a joke; as I take a lot of trouble over my Christmas pictures: some of them take quite a minute to do; and though I only send them to special friends, I have a good many in different places. So just to show him (and to please you) I have copied a whole page from the wall of the chief central cave, and I send you a copy.

It is not, perhaps, quite as well drawn as the originals (which are very, very much larger) – except the goblin parts, which are easy. They are the only parts the Polar Bear can do at all. He says he likes them best, but that is only because he can copy them.

The goblin pictures must be very old, because the goblin fighters are sitting on <u>drasils</u>: a very queer sort of dwarf 'dachshund' horse creature they used to use, but they have died out long ago. I believe the Red Gnomes finished them off, somewhere about Edward the Fourth's time.

The animal drawings are magnificent. The hairy rhinoceros looks wicked. There is also a nasty look in the mammoth's eyes. Also the ox, stag, bear, and cave-bear (portrait of Mr Cave Bear's seventy-first ancestor, he says), and some other kind of polarish but not quite polar bear. North Polar Bear would like to believe it is a portrait of one of his ancestors! Just under the bears is the best a goblin can do at drawing reindeer!!!

You have been so good in writing to me (and such beautiful letters too), that I have tried to draw you some specially nice pictures this year. At the top of my 'Christmas card' is a picture, imaginary, but more or less as it really is, of me arriving over Oxford. Your house is just about where the three little black points stick up out of the shadows at the right. I am coming from the north, and note, NOT with 12 pair of deer, as you will see in some books. I usually use 7 pair (14 is such a nice number), and at Christmas, especially if I am hurried, I add my 2 special white ones in front.

Next comes a picture of me and Cave Bear and North Polar Bear exploring the Caves – I will tell you more about that in a minute. The last picture hasn't happened yet. It soon will. On St Stephen's Day, when all the rush is over, I am going to have a rowdy party: the Cave Bear's grandchildren (they are exactly like live teddy-bears), Snowbabies, some children of the Red Gnomes, and of course Polar Cubs, including Paksu and Valkotukka, will be there.

I'm wearing a pair of new green trousers. They were a present from my green brother, but I only wear them at home. Goblins anyway dislike green, so I found them useful.

You see, when I rescued Polar Bear, we hadn't finished the adventures. At the beginning of last week we went into the cellars to get up the stuff for England. I said to Polar Bear, "Somebody has been disarranging things here!"

"Paksu and Valkotukka, I expect," he said. But it wasn't. Next day things were much worse, especially among the railway things, lots of which seemed to be missing. I ought to have guessed, and Polar Bear anyway, ought to have mentioned his guess to me.

中京东本本文学 4年美人本本本 中中中央水道中本本 本来少年来中等条条头条头来来来来来来来来来来来来来来来来来来 五本本文本本本本 要某多素中央水中 常本美华基子事业 ¥ \$ \$ \$ \$ \$ \$ \$ \$ \$ \$ \$ \$ 本本人来来美丽本本 至人十头字中米大

Last Saturday we went down and found nearly everything had disappeared out of the main cellar! Imagine my state of mind! Nothing hardly to send to anybody, and too little time to get or make enough new stuff.

North Polar Bear said, "I smell goblin strong." Of course, it was obvious: – they love mechanical toys (though they quickly smash them, and want more and more and more); and practically all the Hornby things had gone! Eventually we found a large hole (but not big enough for us), leading to a tunnel, behind some packing-cases in the West Cellar.

As you will expect we rushed off to find Cave Bear, and we went back to the caves. We soon understood the queer noises. It was plain the goblins long ago had burrowed a tunnel from the caves to my old home (which was not so far from the end of their hills), and had stolen a good many things.

We found some things more than a hundred years old, even a few parcels still addressed to your great-grand-people! But they had been very clever, and not too greedy, and I had not found out.

Ever since I moved they must have been busy burrowing all the way to my Cliff, boring, banging and blasting (as quietly as they could). At last they had reached my new cellars, and the sight of the Hornby things was too much for them: they took all they could.

I daresay they were also still angry with the Polar Bear. Also they thought we couldn't get at them. But I sent my patent green luminous smoke down the tunnel, and Polar Bear blew and blew it with our enormous kitchen bellows. They simply shrieked and rushed out the other (cave) end.

But there were Red Gnomes there. I had specially sent for them – a few of the real old families are still in Norway. They captured hundreds of goblins, and chased many more out into the snow (which they hate). We made them show us where they had hidden things, or bring them all back again, and by Monday we had got practically everything back. The Gnomes are still dealing with the goblins, and promise there won't be one left by New Year – but I am not so sure: they will crop up again in a century or so, I expect.

We have had a rush; but dear old Cave Bear and his sons and the Gnome-ladies helped; so that we are now very well forward and all packed. I hope there is not

the faintest smell of goblin about any of your things. They have all been well aired. There are still a few railway things missing, but I hope you will have what you want. I am not able to carry quite as much toy-cargo as usual this year, as I am taking a good deal of food and clothes (useful stuff): there are far too many people in your land, and others, who are hungry and cold this winter.

I am glad that with you the weather is warmish. It is not warm here. We have had tremendous icy winds and terrific snow-storms, and my old house is quite buried. But I am feeling very well, better than ever, and though my hand wobbles with a pen, partly because I don't like writing as much as drawing (which I learned first), I don't think it is so wobbly this year.

The Polar Bear got your father's scribble to-day, and was very puzzled by it. I told him it looked like old lecture-notes, and he laughed. He says he thinks Oxford is quite a mad place if people lecture such stuff: "but I don't suppose anybody listens to it." The drawings pleased him better. He said: "At any rate those boys' father tried to draw bears – though they aren't good. Of course it is all nonsense, but I will answer it."

So he made up an alphabet from the marks in the caves. He says it is much nicer than the ordinary letters, or than Runes, or Polar letters, and suits his paw better. He writes them with the tail of his pen-holder! He has sent a short letter to you in this alphabet – to wish you a very Merry Christmas and lots of fun in the New Year and good luck at School. As you are all so clever now (he says) what with Latin and French and Greek you will easily read it and see that Polar Bear sends much love.

I am not so sure. (Anyway I dare say he would send you a copy of his alphabet if you wrote and asked. By the way he writes it in columns from top to bottom, not across: don't tell him I gave away his secret).

This is one of my very longest letters. It has been an exciting time. I hope you will like hearing about it. I send you all my love: John, Michael, Christopher, and Priscilla: also Mummy and Daddy and Auntie and all the people in your house. I dare say John will feel he has got to give up stockings now and give way to the many new children that have arrived since he first began to hang his up; but Father Christmas will not forget him. Bless you all.

Your loving, Nicholas Christmas.

Mr.

North Pole. Dec. 2nd. 1493.

Near North Pole
December 2nd 1933

Dear People,

Very cold here at last. Business has really begun, and we are working hard. I have had a good many letters from you. Thank you. I have made notes of what you want so far, but I expect I shall hear more from you yet – I am rather short of messengers – the goblins have— but I haven't time to tell you about our excitements now. I hope I shall find time to send a letter later.

Give John my love when you see him. I send love to all of you, and a kiss for Priscilla – tell her my beard is quite nice and soft, as I have never shaved.

Three weeks to Christmas Eve!

Yours, Father Nicholas Christmas

Cheer up, chaps (Also chaplet, if that's the feminine). The fun's beginning!

Yours, Polar Bear

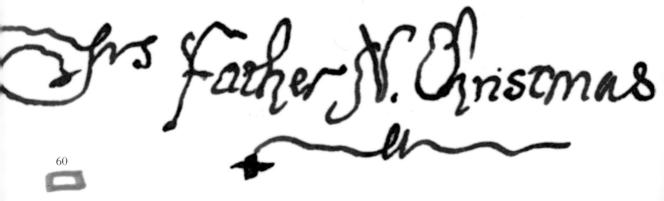

Cliff House, near the North Pole December 21st 1933

My dears

Another Christmas! and I almost thought at one time (in November) that there would not be one this year. There would be the 25th of December, of course, but nothing from your old great-great-etc. grandfather at the North Pole.

Goblins. The worst attack we have had for centuries. They have been fearfully wild and angry ever since we took all their stolen toys off them last year and dosed them with green smoke. You remember the Red Gnomes promised to clear all of them out. There was not one to be found in any hole or cave by New Year's day. But I said they would crop up again – in a century or so.

They have not waited so long! They must have gathered their nasty friends from mountains all over the world, and been busy all the summer while we were at our sleepiest. This time we had very little warning.

Soon after All Saints' Day, Polar Bear got very restless. He now says he smelt nasty smells – but as usual he did not say anything: he says he did not want to trouble me. He really is a nice old thing, and this time he absolutely saved Christmas. He took to sleeping in the kitchen with his nose towards the cellar-door, opening on the main-stairway down into my big stores.

One night, just about Christopher's birthday, I woke up suddenly. There was squeaking and spluttering in the room and a nasty smell – in my own best green and purple room that I had just had done up most beautifully. I caught sight of a wicked little face at the window. Then I really was upset, for my window is high up above the cliff, and that meant there were bat-riding goblins about – which we haven't seen since the goblin-war in 1453, that I told you about.

I was only just quite awake, when a terrific din began far downstairs – in the store-cellars. It would take too long to describe, so I have tried to draw a picture of what I saw when I got down – after treading on a goblin on the mat.

Only ther was more like 1000 goblins than 15.

(But you could hardly expect me to draw 1000). Polar Bear was squeezing, squashing, trampling, boxing and kicking goblins skyhigh, and roaring like a zoo, and the goblins were yelling like engine whistles. He was splendid.

Say no more - I enjoyed it immensely!

Well, it is a long story. The trouble lasted for over a fortnight, and it began to look as if I should never be able to get my sleigh out this year. The goblins had

set part of the stores on fire and captured several gnomes, who sleep down there on guard, before Polar Bear and some more gnomes came in – and killed 100 before I arrived.

Even when we had put the fire out and cleared the cellars and house (I can't think what they were doing in my room, unless they were trying to set fire to my bed) the trouble went on. The ground was black with goblins under the moon when we looked out, and they had broken up my stables and gone off with the reindeer.

I had to blow my golden trumpet (which I have not done for many years) to summon all my friends. There were several battles – every night they used to attack and set fire in the stores – before we got the upper hand, and I am afraid quite a lot of my dear elves got hurt.

Fortunately we have not lost much except my best string, (gold and silver) and packing papers and holly-boxes. I am very short of these: and I have been very short of messengers. Lots of my people are still away (I hope they will come back safe) chasing the goblins out of my land, those that are left alive.

They have rescued all my reindeer. We are quite happy and settled again now, and feel much safer. It really will be centuries before we get another goblin-trouble. Thanks to Polar Bear and the gnomes, there can't be very many left at all.

And Father Christmas. I wish I could draw or had time to try – you have no idea what the old man can doo! Litening and fierworks and thunder of guns!

Polar Bear certainly has been busy helping, and double help – but he has mixed up some of the girls' things with the boys' in his hurry. We hope we have got all sorted out – but if you hear of anyone getting a doll when they wanted an engine, you will know why. Actually Polar Bear tells me I am wrong – we did lose a lot of railway stuff – goblins always go for that – and what we got back was damaged and will have to be repainted. It will be a busy summer next year.

Now, a merry Christmas to you all once again. I hope you will all have a very happy time; and will find that I have taken notice of your letters and sent you what you wanted. I don't think my pictures are very good this year – though I took quite a time over them (at least two minutes). Polar Bear says, "I don't see that a lot of stars and pictures of goblins in your bedroom are so frightfully merry." Still I hope you won't mind. It is rather good of Polar Bear kicking, really. Anyway I send lots of love.

Yours ever and annually Father Nicholas Christmas.

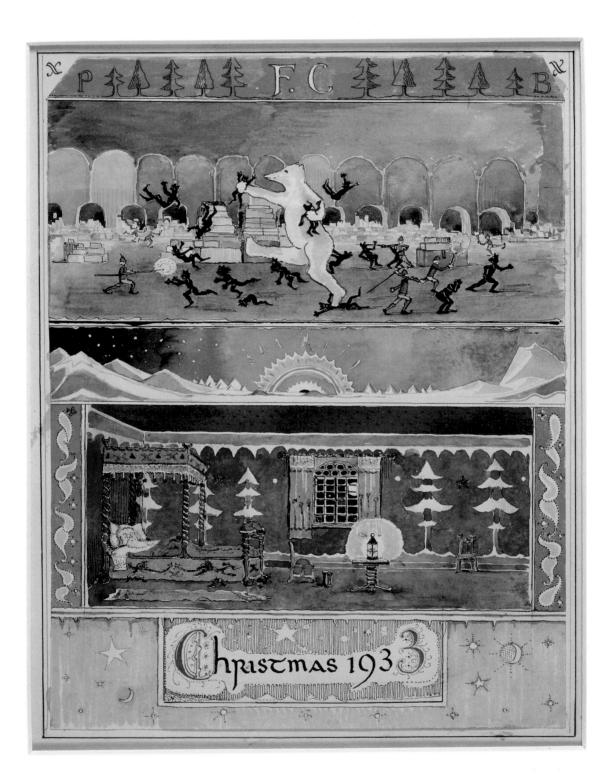

1934

!! To messenger: Deliver at once and don't stop on the way!!

At once Urgent Express!

My dear Christopher

Thank you! I am awake – and have been a long while. But my post office does not really open ever until Michaelmas. I shall not be sending my messengers out regularly this year until about October 15th. There is a good deal to do up here. Your telegram – that is why I have sent an express reply – and letter and Priscilla's were found quite by accident: not by a messenger but by Bellman (I don't know how he got that name because he never rings any; he is my chimney inspector and always begins work as soon as the first fires are lit).

Very much love to you and Priscilla. (The Polar Bear, if you remember him, is still fast asleep, and quite thin after so much fasting. He will soon cure that. I shall tickle his ribs and wake him up soon; and then he will eat several months' breakfast all in one).

More love, your loving Father Christmas

Dy dear Christopher

Cliff House, North Pole Christmas Eve. 1934

My dear Christopher

Thank you very much for your many letters. I have not had time this year to write you so long a letter as 1932 and 1933, but nothing at all exciting has happened. I hope I have pleased you with the things I am bringing and that they are near enough to your lists.

Very little news: after the frightful business of last year there has not been even a smell of goblin for 200 miles round. But, as I said it would, it took us far into the summer to repair all the damage, and we lost a lot of sleep and rest.

When November came round we did not feel like getting to work, and we were rather slow and so have been rushed at the end. Also it has been unusually warm for the North Pole, and the Polar Bear still keeps on yawning.

Paksu and Valkotukka have been here a long while. They have grown a good deal – but still get up to frightful mischief in between times of trying to help. This year they stole my paints and painted scrawls on the white walls of the cellars; ate all the mincemeat out of the pies made ready for Christmas; and only yesterday went and unpacked half the parcels to find railway things to play with!

They don't get on well with the Cave cubs, somehow; several of these have arrived today and are staying here a few nights with old Cave Brown Cave, who is their uncle, granduncle, grandfather, great granduncle, etc. Paksu is always kicking them because they squeak and grunt so funnily: Polar Bear has to box him often – and a 'box' from Polar Bear is no joke.

As there are no Goblins about, and as there is no wind, and so far much less snow than usual, we are going to have a great boxing-day party ourselves – out of doors. I shall ask 100 elves and red gnomes, lots of polar cubs, cave-cubs, and snowbabies, and of course, Paksu and Valkotukka, and Polar Bear and Cave Bear and his nephews (etc.) will be there.

We have brought a tree all the way from Norway and planted it in a pool of ice. My picture gives you no idea of its size, or of the loveliness of its magic lights of different colours. We tried them yesterday evening to see if they were all right. If you see a bright glow in the North you will know what it is!

Behind the tree are snowplants, and piled masses of snow made into ornamental shapes – they are purple and black because of darkness and shadow. There is also a special edging to the icepool – and it is made of real coloured icing. Paksu and Valkotukka are already nibbling at it, though they should not – till the party.

Polar Bear started to draw this to help me, as I was busy, but he dropped such blots – enormous ones. I had to come to the rescue. Not very good this year. Never mind: perhaps better next year.

I hope you will like your presents and be very happy.

Your loving Father Christmas.

PS I really can't remember exactly in what year I was born. I doubt if anyone knows. I am always changing my own mind about it. Anyway it was 1934 years ago or jolly nearly that. Bless you! FC

PPS Give my love to Mick and John.

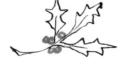

Polar Bear LOVE BISY THANKS

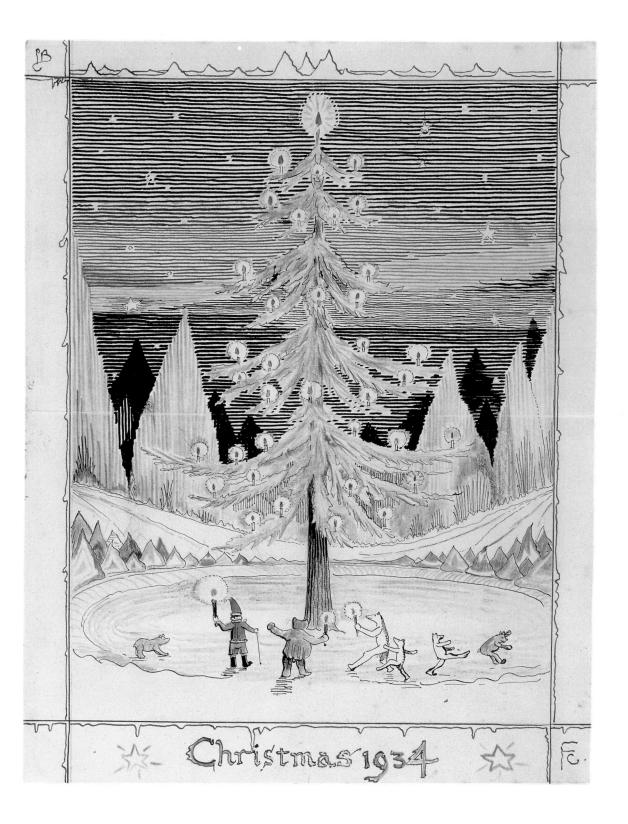

My dear Children

Here we are again. Christmas seems to come round pretty soon again: always much the same and always different. No ink this year and no water, so no painted pictures; also very cold hands, so very wobbly writing.

This is a picture of my house about a week ago before we got the reindeer sheds dug out. We had to make a tunnel to the front door. There are only three windows upstairs shining through holes - and there is steam where the snow is melting off the dome and roof.

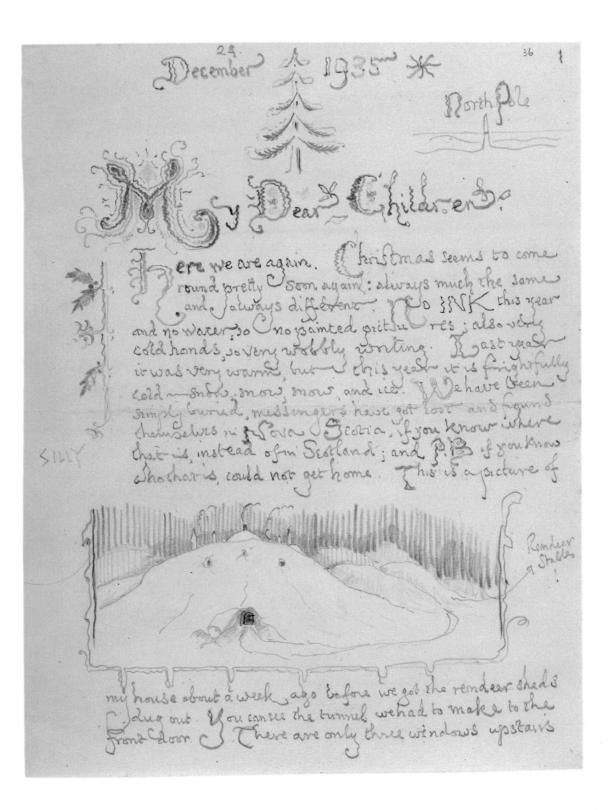

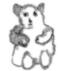

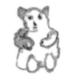

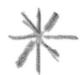

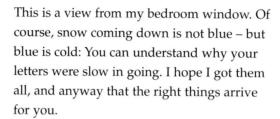

Poor old PB, if you know who I mean, had to go away soon after the snow began last month. There was some trouble in his family, and Paksu and Valkotukka were ill. He is very good at doctoring anybody but himself.

But it is a dreadfully long way over the ice and snow – to North Greenland I believe. And when he got there he could not get back. So I have been rather held up, especially as the Reindeer stables and the outdoor store sheds are snowed over.

I have had to have a lot of Red Elves to help me. They are very nice and great fun; but although they are very quick they don't get on fast. For they turn everything into a game. Even digging snow. And they will play with the toys they are supposed to be packing.

Shining through holes - but you can see steam where the Usnow is melling off the dome and roofs. This a view from my bedroom window of volume snow coming downis not blue - but blue is Esta: you can understand why your letters were slowing going Shope I got Other all and anyway SILLY Things arrive for you. AGAIN mean had rodo away som after the snow began last month. There was son bunkle in his family, and Jaksu & Valkotukka west ill. very good at doctoring any body but himself. I itch's a dreadfully long way over the ice and snow & Gord Greedland Ibelieve. And when he god there he could not get back. So Thave been rather held up, especially as the & condiers tables and the outson stone shedd are snowed out. I have had to have a low of Red Elves is help me. They are very rice I great fun strat although they are very quick they don't get on fast. For they turn everything into a game O Even Ligging snow And they will slay with

PB, if you remember him, did not get back until Friday December 13th – so that proved a lucky day for me after all!

(HEAR HEAR!)

Even he had to wear a sheepskin coat and red gloves for his paws. And he had got a hood on and red gloves. He thinks he looks rather like Rye St Anthony. But of course he does not very much. Anyway he carries things in his hood – he brought home his sponge and soap in it!

He says that we have not seen the last of the goblins – in spite of the battles in 1933. They won't dare to come into my land yet; but for some reason they are breeding again and multiplying all over the world. Quite a nasty outbreak. But there are not so many in England, he says. I expect I shall have trouble with them soon.

I have given my elves some new magic sparkler spears that will scare them out of their wits. It is now December 24th and they have not appeared this year – and practically everything is packed up and ready. I shall be starting soon

the toys they are supposed to be 13 asking. B. From remember him, did I not get back until se stember the 13th - so that proved a lucky day NAMIN forme (HEXR MEAR) after all, Even a sheep skin coat & red gloves for gloves for his paws. And a hood on and red her lad got thinks he looks gloves the Ede St Jolhony Burofsours he closes not ven much. Fing way he carries things in his hood - he brought Chame his sponge was soones on esays that we have now seen the East of the 3 38 2ins - maprice of the Gardles in 2983. They dare to come into my land yet; but for some reason they are breeding Cagain and multiplying The world CESmer a nasty outbreaken! sur there are not somand in England, he says. expect I shall have I brouble is with them soon. Thave given my elves Some new magic sparkler spears & Will Stare them our of their wits S. This now December 34 and they have not appeared This year - and practicall everything 33 is packed Shall be starting soon up Conce ready, I

Send you all - John & Michael & 32 Spher on a Sewif you don't want them all. ill In Ease you don't know O get I learn lots of news O even in Snowy Oweather) ear fron Bank to write and rell me everything toosail new Thopse you enjoy th 38 ? & Varewellagon. Only Springs. They will bearmy by party on St Freshens Day with other polar cubs, cave into showbatries, elucs, and all the rest

Cliff House North Pole Wednesday Dec. 23rd 1936

My dear Children

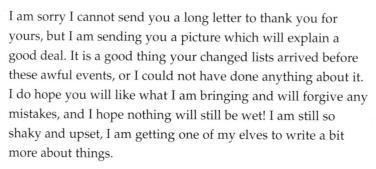

I send very much love to you all.

Father Christmas says you will want to hear some news. Polar Bear has been quite good – or had been – though he has been rather tired. So has Father Christmas; I think the Christmas business is getting rather too much for them.

So a lot of us, red and green elves, have gone to live permanently at Cliff House, and be trained in the packing business. It was Polar Bear's idea. He also invented the number system, so that every child that Father Christmas deals with has a number and we elves learn them all by heart, and all the addresses. That saves a lot of writing.

Wednesday Dec 23rd 1036 My dear Children long letter to thank you for yours, but 1) am sonding you a hicture which will explain a good deal 1) It is a good thing your changed lists arrived before these Jawh wents, Oor I could not have done anything about it. I do hopse you will like what I fame bringing and will forgive any mistakes, & Trope nothing will still be I wet! still so shaky and upset Jam getting one of my elves to write a bet more about Thinas Of send very much love to you all father C. says you will want to hear some news. PB has been quete good - Joshad been - though he has been rather bired. So has F.C. Ithink The Christmas business is getting rather too much for them. So I lot of us, red and green elves, have gone to live permanently at Cliff House, and be brained in the packing business. Hwas P.B's idea. He also invented the number system, so that every child that f.C. deals with has a number and we elvo learn them all by heart, and all the addresses. That saves

So many children have the same name that every packet used to have the address as well. Polar Bear said: "I am going to have a record year and help Father Christmas to get so forward we can have some fun ourselves on Christmas day."

We all worked hard, and you will be surprised to hear that every single parcel was packed and numbered by Saturday (December 19th). Then Polar Bear said "I am tired out: I am going to have a hot bath, and go to bed early!"

Well you can guess what happened. Father Christmas was taking a last look round in the English Delivery Room about 10 o'clock when water poured through the ceiling and swamped everything: it was soon 6 inches deep on the floor. Polar Bear had simply got into the bath with both taps running and gone fast asleep with one hind paw on the overflow. He had been asleep two hours when we woke him.

Father Christmas was really angry. But Polar Bear only said: "I did have a jolly dream. I dreamt I was diving off a melting iceberg and chasing seals."

He said later when he saw the damage: "Well there is one thing: those children at Northpole Road, Oxford (he always says that) may lose some of their presents, but they will have a letter worth hearing this year. They can see a joke, even if none of you can!"

That made Father Christmas angrier, and Polar Bear said: "Well, draw a picture of it and ask them if it is funny or not." So Father Christmas has. But he has begun to think it funny (although very annoying) himself, now we have cleared up the mess, and got the English presents repacked again. Just in time. We are all rather tired, so please excuse scrawly writing.

Yours, Ilbereth, Secretary to Father Christmas

Very sorry. Been bizy. Can't find that alphabet. Will look after Christmas and post it. Yours, Polar Bear.

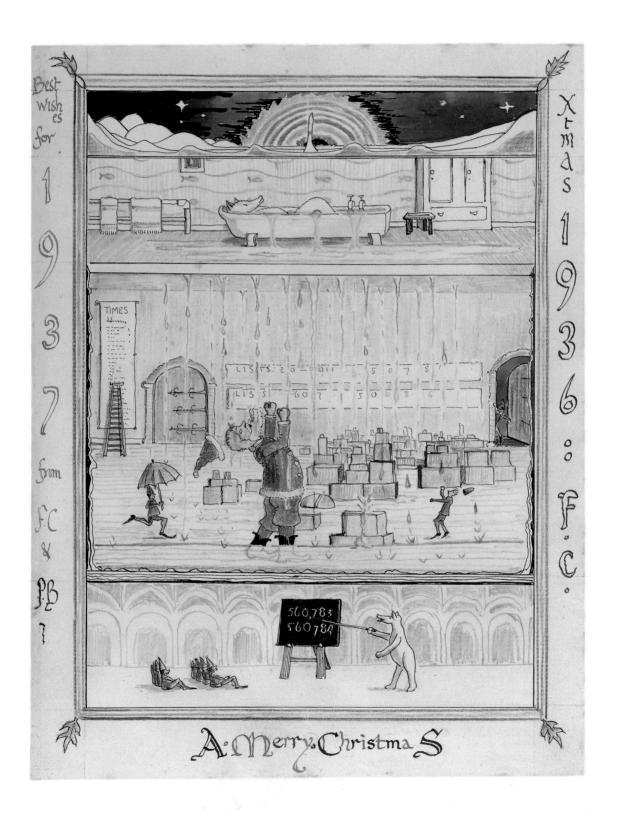

HAVE FOUND IT. I SEND YOU A COPY. YOU NEEDNT. FILL IN BLACK PARTS IF YOU DON'T WANT TO IT TO REST RATHER LONG TO RITE BLY I THINK IT IS RATHER CLEVER.

STILL BIZY. F. SEZI CAN'T HAVE A BATH TILL NEXT YEAR LOVE TOLLYO BOTH BICALISE YOU SEE JOKES

I GOT INTO HOT WATER DIDN'T? HA! HA! PB.

42

I have found it. I send you a copy. You needn't fill in black parts if you don't want to. It takes rather long to rite but I think it is rather clever.

Still bizy. Father Christmas sez I can't have a bath till next year.

Love tou yo both bicause you see jokes

Polar Bear

I got into hot water didn't I? Ha! Ha!

SOBLIN 43 ALPHABET All ora A X PAI L PORT 8 \$ M C KCHK N # OF YOA
D * P P PH FOUNT POI PEN S Y JISH St NG FY TH DOVBLE SIGN G G G U G WH V G G WH I P X X X T) = EE Q= and to 各人是了。各方外。 常 K X ick X

Cliff House, North Pole Christmas 1937

My dear Christopher and Priscilla, and other old friends in Oxford: here we are again!

Of course I am always here (when not travelling), but you know what I mean. Christmas again. I believe it is 17 years since I started to write to you. I wonder if you have still got all my letters? I have not been able to keep quite all yours, but I have got some from every year.

We had quite a fright this year. No letters came from you. Then one day early in December I sent a messenger who used to go to Oxford a lot but had not been there for a long while, and he said: "Their house is empty and everything is sold." I was afraid something had happened, or that you had all gone to school in some other town, and your father and mother had moved. Of course, I know now; the messenger had been to your old house next door! He complained that all the windows were shut and the chimneys all blocked up.

I was very glad indeed to get Priscilla's first letter, and your two nice letters, and useful lists and hints, since Christopher came back. I quite understand that School makes it difficult for you to write like you used. And of course I have new children coming on my lists each year so that I don't get less busy.

Tell your father I am sorry about his eyes and throat: I once had my eyes very bad from snow-blindness, which comes from looking at sunlit snow. But it got better. I hope Priscilla and

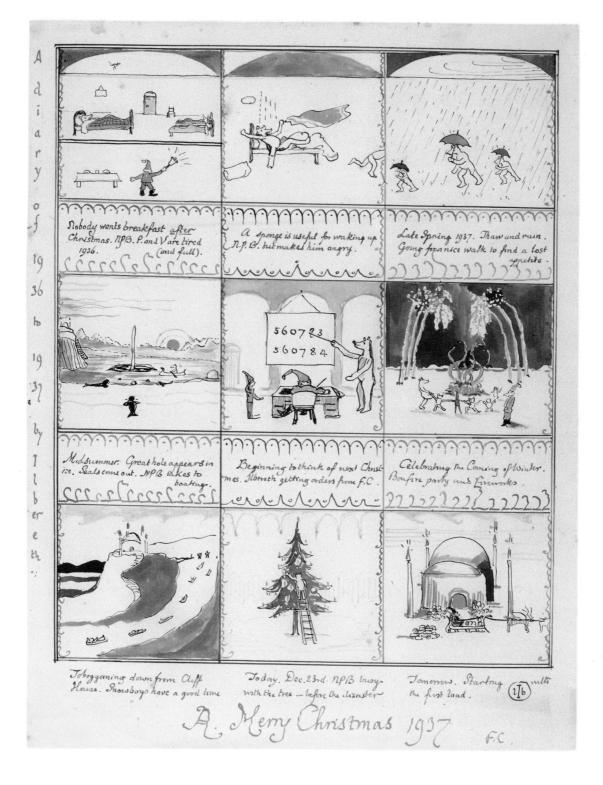

your Mother and everyone else will be well on Dec. 25. I am afraid I have not had any time to draw you a picture this year. You see I strained my hand moving heavy boxes in the cellars in November, and could not start my letters until later than usual, and my hand still gets tired quickly. But Ilbereth – one of the cleverest Elves who I took on as a secretary not long ago – is becoming very good.

He can write several alphabets now – Arctic, Latin (that is ordinary European like you use), Greek, Russian, Runes, and of course Elvish. His writing is a bit thin and slanting – he has a very slender hand – and his drawing is a bit scratchy, I think. He won't use paints – he says he is a secretary and so only uses ink (and pencil). He is going to finish this letter for me, as I have to do some others.

So I will now send you lots of love, and I do hope that I have chosen the best things out of your suggestion lists. I was going to send 'Hobbits' – I am sending away loads (mostly second editions) which I sent for only a few days ago) – but I thought you would have lots, so I am sending another Oxford Fairy Story.

Lots and Lots of Love, Father Christmas

Dear Children:

I am Ilbereth. I have written to you before. I am finishing for Father Christmas. Shall I tell you about my pictures? Polar Bear and Valkotukka and Paksu are always lazy after Christmas, or rather after the St Stephen's Day party. Father Christmas is ringing for breakfast in vain. Another day when Polar Bear, as usual, was late

not true!

Paksu threw a bath-sponge full of icy water on his face. Polar Bear chased him all round the house and round the garden and then forgave him, because he had not caught Paksu, but had found a huge appetite.

We had terrible weather at the end of winter and actually had rain. We could not go out for days. I have drawn Polar Bear and his nephews when they did venture out. Paksu and Valkotukka have never gone away. They like it so much that they have begged to stay.

It was much too warm at the North Pole this year. A large lake formed at the bottom of the Cliff, and left the North Pole standing on an island. I have drawn a view looking South, so the Cliff is on the other side. It was about mid-summer. The North Polar Bear, his nephews and lots of polar cubs used to come and bathe. Also seals. North Polar Bear took to trying to paddle a boat or canoe, but he fell in so often that the seals thought he liked it, and used to get under the boat and tip it up. That made him annoyed.

The sport did not last long as the water froze again early in August. Then we began to begin to think of this Christmas. In my picture Father Christmas is dividing up the lists and giving me my special lot – you are in it.

North Polar Bear of course always pretends to be managing everything: that's why he is pointing, but I am really listening to Father Christmas and I am saluting him not North Polar Bear.

Rude little errand boy.

We had a glorious bonfire and fireworks to celebrate the Coming of Winter and the beginning of real 'Preparations'. The Snow came down very thick in November and the elves and snowboys had several tobogganing half-holidays. The polar cubs were not good at it. They fell off, and most of them took to rolling or sliding down just on themselves. Today — but this is the best bit, I had just finished my picture, or I might have drawn it differently.

And better!

Polar Bear was being allowed to decorate a big tree in the garden, all by himself and a ladder. Suddenly are heard terrible growly squealy noises. We rushed out to find Polar Bear hanging on the tree himself!

"You are not a decoration," said Father Christmas. "Anyway, I am alight," he shouted.

He was. We threw a bucket of water over him. Which spoilt a lot of the decorations, but saved his fur. The silly old thing had rested the ladder against a

branch (instead of the trunk of the tree). Then he thought, "I will just light the candles to see if they are working," although he was told not to. So he climbed to the tip of the ladder with a taper. Just then the branch cracked, the ladder slipped on the snow, and Polar Bear fell into the tree and caught on some wire; and his fur got caught on fire.

Poor joke.

Luckily he was rather damp or he might have fizzled. I wonder if roast Polar is good to eat?

Not as good as well spanked and fried elf.

The last picture is imaginary and not very good. But I hope it will come true. It will if Polar Bear behaves. I hope you can read my writing. I try to write like dear old Father Christmas (without the trembles), but I cannot do so well. I can write Elvish better:

That is some – but Father Christmas says I write even that too spidery and you would never read it.

Love Ilbereth.

A big hug and lots of love. Enormous thanks for letters. I don't get many, though I work so harrd. I am practising new writing with lovely thick pen. Quicker than Arctick. I invented it.

Ilbereth is cheky. How are the Bingos? A merry Christmas. North Polar Bear

AND BENNER! We had a glorious benfire and prevorks to celebrate the Coming of Winter and the beginning of real Preparations'. The Snow came down very thick in November and the clues land mastrys had several tologganing half holidage. The plan calls were not good about . They fee of , and most ofther book to rolling on - but this ig the best but. gliding down just on themselves. Today I had just finished my prehore, or I might have drawn it differently. P.B. was being allowed to decorate a buy trei in the garden , all by hunself and a ladden. Suddenly are heard temble growly squealy noises. We nished out to find fit hanging in the bree himself! You great a decoration sand F. C. NEINNER Shyrory I am alight 'he Montes. He was. We threw alucket of water over him Which spoilt a lot ofthe decorations, but saved his fir. The selly do mong had rested the ladder against a branch (ustead of the Bruk ofthe hee). Then he thought, I mell just hight the candles to see if they are working "alltough he was to to to. So he claimled to the tips of the ladder write a taper. Just then the branch cracker, the ladder slegged on the snow, and f13. fell who he tree and cought on some wire; and his fur got cought on pre. Lickely he was ruleer dains or he might have fizzled. I moder if roust Planes good to cat? The last picher is miaginary

and not very good. But Thope drill come bre. Itali if P.B. behaves. Thope ym can read my withing. I by to write like dear old F.C (anternt the bremble) but I cannot do so well. Hem write blish better. [- fing y' ingy, Tyllipmet, por no er- thatis same - but fc. somp I inte even that he yndery and ynd women never read it : it's any A very

ENON AS GOODAS WELL SPANKED AND FRIED ELF

meny Clino mas to you all. Love Obereth

POOR

JOKE

MATART Thatis Runick. NPB Abig hug and lors of love. Enormous thanks for letters I don't get many, though I work so harred Jam practising new writing with lovely thick pen. Qui ker than Archek I invented TUBEREAH ISCHEKY. HOW ARE AHE A MERRY (MRIST Vaksu's now > (mark (I)

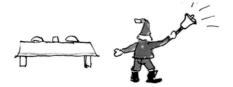

Cliff House, North Pole Christmas 1938

My dear Priscilla and all others at your house

Here we are again! Bless me, I believe I said that before – but after all you don't want Christmas to be different each year, do you?

I am frightfully sorry that I haven't had the time to draw any big picture this year, and Ilbereth (my secretary) has not done one either; but we are all sending you some rhymes instead. Some of my other children seem to like rhymes, so perhaps you will.

We have all been very sorry to hear about Christopher. I hope he is better and will have a jolly Christmas. I only heard lately when my messengers and letter collectors came back from Oxford. Tell him to cheer up – and although he is now growing up and leaving stockings behind, I shall bring a few things along this year. Among them is a small astronomy book which gives a few hints on the use of telescopes – thank you for telling me he had got one. Dear me! My hand is shaky – I hope you can read some of this?

I loved your long letter, with all the amusing pictures. Give my love to your Bingos and all the other sixty (or more!), especially Raggles and Preddley and Tinker and Tailor and Jubilee and Snowball. I hope you will go on writing to me for a long while yet.

Very much love to you – and lots for Chris – from

Father Christmas

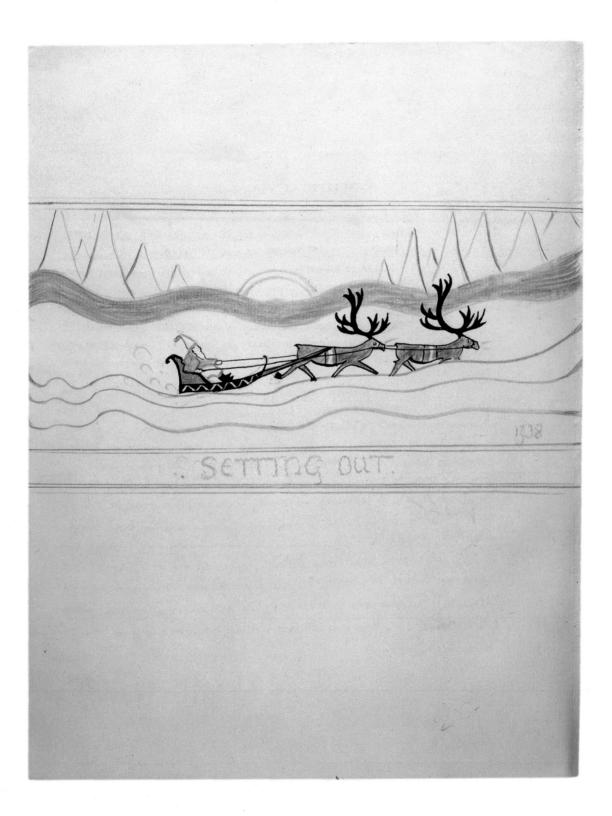

Again this year, my dear Priscilla, when you're asleep upon your pillow;

Bad rhyme! That's beaten you!

beside your bed old Father Christmas

[The English language has no rhyme to Father Christmas: that's why I'm not very good at making verses.

But what I find a good deal worse is that girls' and boys' names won't rhyme either (and bother! either won't rhyme neither).

So please forgive me, dear Priscilla, if I pretend you rhyme with pillow!]

She won't.

As I was saying -

beside your bed old Father Christmas (afraid that any creak or hiss must

How's that?

Out!

wake you up) will in a twinkling fill up your stocking, (I've an inkling that it belongs, in fact, to pater - but never mind!) At twelve, or later, he will arrive – and hopes once more that he has chosen from his store

I did it.

the things you want. You're half past nine;

She is not a clock!

but still I hope you'll drop a line for some years yet, and won't forget old Father Christmas and his Pet, the North Polar Bear (and Polar Cubs as fat as little butter-tubs), and snowboys and Elves – in fact the whole of my household up near the Pole.

hyme. gain this year, my dearily BAD chyme! when you're askeep upon your pillow; beside your bed old Father Christmas that's beaten you! he English alanguage has no rhyme Ito father Christmas: that's why I'm not very good at making verses. But what I find a good deal worse is that girls and boy's names won't rhyme either (and bother! either won't shume neither). So please forgive me, dear Pristilla, she won't I pretond you shame with pillow! I was saying beside your bed old father Christmas (afraid that any creak or hiss must wake young) will in a twinkling OUT! Fill up your stocking I've an inkling that it belongs, in fact to pater but never mind! At twelve, or later, he will arrive - and hopes once more 1 did in that he has chosen from his store She is not a clock the things you want. You're half past nine; but still I hope you'll drop a line for some years yet, by won't forget Shots by P. M. A old father Christmas and his Det, the N. P. 13 (and Polar Cubs as fat as little butter tubs) out snowboys and fives—in fact the whole of myhousehold up near—the Pole. Upon my tist made in December. Your number is, if you remember, Sifty six thousand, seven hundred, weak! and eighty five. It can't be wondered at that Jam so busy, when you think that you are nearly ten,

Upon my list, made in December, your number is, if you remember, fifty six thousand, seven hundred, and eighty five. It can't be wondered

at that I am so busy, when you think that you are nearly ten, and in that time my list has grown by quite ten thousand girls alone, even when I've subtracted all the houses where I no longer call!

You all will wonder what's the news; if all has gone well, and if not who's to blame; and whether Polar Bear has earned a mark good, bad, or fair, for his behaviour since last winter.

Well – first he trod upon a splinter,

Weak!

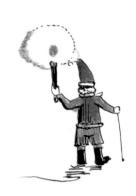

Just rhiming nonsens: it was a nail – rusty, too

and went on crutches in November; and then one cold day in December he burnt his nose and singed his paws upon the Kitchen grate, because without the help of tongs he tried to roast hot chestnuts. "Wow!" he cried,

I never did!

and used a pound of butter (best) to cure the burns. He would not rest,

I was not given a chance.

but on the twenty-third he went and climbed up on the roof. He meant to clear the snow away that choked his chimney up – of course he poked his legs right through the tiles and snow

in tons fell on his bed below. He has broken saucers, cups, and plates; and eaten lots of chocolates; he's dropped large boxes on my toes, and trodden tin-soldiers flat in rows;

You need not believe all this!

You need!

he's over-wound engines and broken springs, and mixed up different children's things; he's thumbed new books and burst balloons and scribbled lots of smudgy Runes on my best paper, and wiped his feet on scarves and hankies folded neat – And yet he has been, on the whole, a very kind and willing soul. He's fetched and carried, counted, packed and for a week has never slacked:

here hear!

I wish you wouldn't scribble on my nice rhyme!

he's climbed the cellar-stairs at least five thousand times – the Dear Old Beast!

Paksu sends love and Valkotukka -

They are still with me, and they don't look a year older, but they're just a bit more wise, and have a pinch more wit.

The GOBLINS, you'll be glad to hear, have not been seen at all this year, not near the Pole. But I am told, they're moving south, and getting bold, and coming back to many lands, and making with their wicked hands new mines and caves. But do not fear! They'll hide away, when I appear.

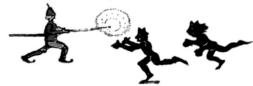

Christmas Day

Now Christmas Day has come round again and poor North Polar Bear has got a bad pain! They say he's swallowed a couple of pounds of nuts without cracking the shells! It sounds a Polarish sort of thing to do but that isn't all, between me and you: he's eaten a ton of various goods and recklessly mixed all his favourite foods, honey with ham and turkey with treacle, and pickles with milk. I think that a week'll be needed to put the old bear on his feet. And I mustn't forget his particular treat: plum pudding with sausages and turkish delight covered with cream and devoured at a bite! And after this dish he stood on his head it's rather a wonder the poor fellow's not dead!

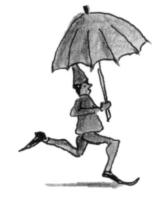

Absolute ROT: I have not got a pain in my pot.

I do not eat turkey or meat: I stick to the sweet. Which is why (as all know) I am so sweet myself, you thinuous elf!

Goodby!

Rude fellow!

He means fatuous

No I don't, you're not fat, but thin and silly.

You know my friends too well to think (although they're rather rude with ink) that there are really quarrels here!
We've had a very jolly year
(except for Polar Bear's rusty nail);
but now this rhyme must catch the Mail – a special messenger must go,

in spite of thickly falling snow, or else this won't get down to you on Christmas day. It's half past two! We've quite a ton of crackers still to pull, and glasses still to fill! Our love to you on this Noel – and till the next one, fare you well!

Father Christmas

Polar Bear

Ilbereth

Paksu and Valkotukka

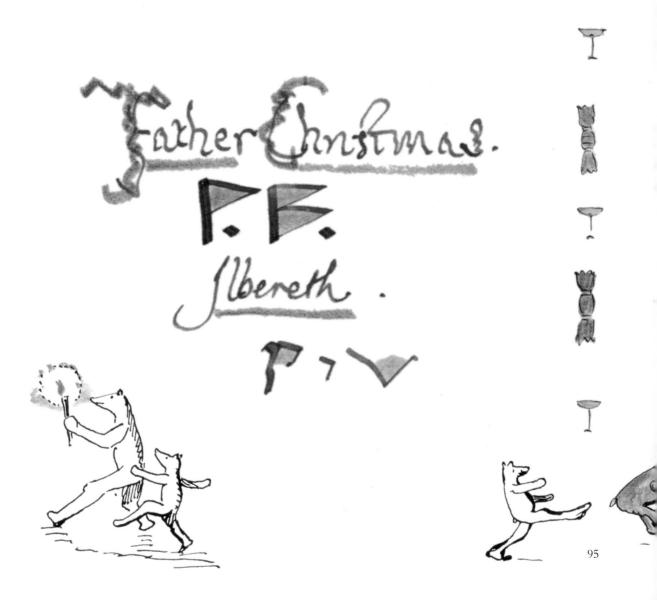

Cliff House, NORTH POLE December 24th 1939

My dear Priscilla

I am glad you managed to send me two letters although you have been rather busy working. I hope your Bingo family will have a jolly Christmas, and behave themselves. Tell Billy – is not that the father's name? - not to be so cross. They are not to quarrel over the crackers I am sending.

I am very busy and things are very difficult this year owing to this horrible war. Many of my messengers have never come back. I haven't been able to do you a very nice picture this year. It is supposed to show me carrying things down our new path to the sleigh-sheds. Paksu is in front with a torch looking most frightfully pleased with himself (as usual). There is just a glimpse (quite enough) of Polar Bear strolling along behind. He is of course carrying nothing.

There have been no adventures here, and nothing funny has happened - and that is because Polar Bear has done hardly anything to "help", as he calls it, this year.

ROT!

I don't think he has been lazier than usual, but he has been not at all well. He ate some fish that disagreed with him last November and was afraid he might have to go to hospital in Greenland. But after living only on warm water for a fortnight he suddenly threw the glass and jug out of the window and decided to get better.

He drew the trees in the picture, and I am afraid they are not very good.

Best part of it

They look more like umbrellas! Still he sends love to you and all your bears. "Why don't you have Polar Cubs instead of Bingos and Koalas?" he says.

Why not?

Give my love to Christopher and Michael and to John when you next write.

Love from Father Christmas.

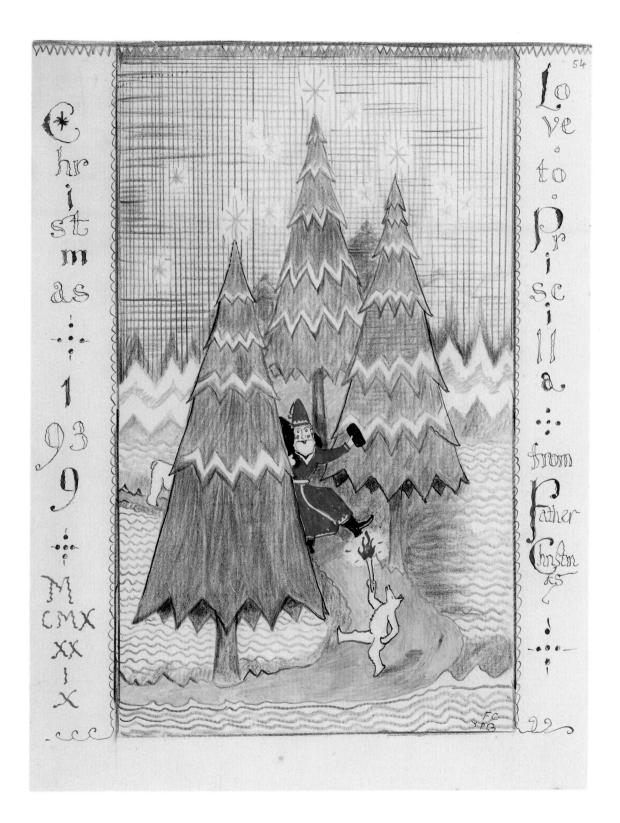

December 23rd 1940

Dear Priscilla

Glad to find you are back! Message came on Saturday that your house was empty. Wos afrade you had gon without leaving any address.

Ar having verry DIFFICULT time this year but ar doing my our best .

THANK YOU for explaining about your room. Father Christmas sends love! Please excuse blots. Rather bizzy.

Yours Polar Bear

2am. Pec. 13 le FR. CHRIST MAS. SAYS nofdont

I sky all right

•

Cliff House, near North Pole Christmas Eve 1940

My Dearest Priscilla

Just a short letter to wish you a very happy Christmas. Please give my love to Christopher. We are having rather a difficult time this year. This horrible war is reducing all our stocks, and in so many countries children are living far from their homes. Polar Bear has had a very busy time trying to get our address-lists corrected. I am glad you are still at home!

I wonder what you will think of my picture. "Penguins don't live at the North Pole," you will say. I know they don't, but we have got some all the same. What you would call "evacuees", I believe (not a very nice word); except that they did not come here to escape the war, but to find it! They had heard such stories of the happenings up in the North (including a quite untrue story that Polar Bear and all the Polar Cubs had been blown up, and that I had been captured by Goblins) that they swam all the way here to see if they could help me. Nearly 50 arrived.

The picture is of Polar Bear dancing with their chiefs. They amuse us enormously: they don't really help much, but are always playing funny dancing games, and trying to imitate the walk of Polar Bear and the Cubs.

Very much love from your old friend, Father Christmas

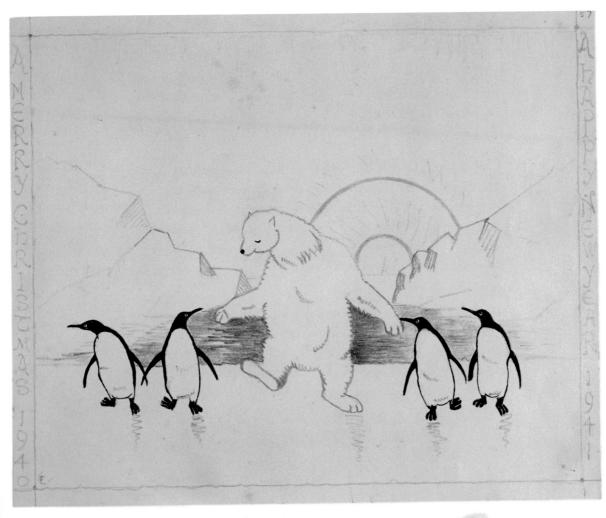

Chrismas Eve

Cliff House, near (stump of) North Pole December 22nd, 1941

My Dearest Priscilla,

I am so glad you did not forget to write to me again this year. The number of children who keep up with me seems to be getting smaller: I expect it is because of this horrible war, and that when it is over things will improve again, and I shall be as busy as ever. But at present so terribly many people have lost their homes: or have left them; half the world seems in the wrong place.

And even up here we have been having troubles. I don't mean only with my stores: of course they are getting low. They were already last year, and I have not been able to fill them up, so that I have now to send what I can instead of what is asked for. But worse than that has happened.

I expect you remember that some years ago we had trouble with the Goblins; and we thought we had settled it. Well, it broke out again this autumn, worse than it has been for centuries. We have had several battles, and for a while my house was besieged. In November it began to look likely that it would be captured and all my goods, and that Christmas Stockings would all remain empty all over the world.

Would not that have been a calamity? It has not happened – and that is largely due to the efforts of Polar Bear –

N.B. That's mee!

but it was not until the beginning of this month that I was able to send out any messengers! I expect the Goblins thought that with so much war going on this was a fine chance to recapture the North. They must have been preparing for some years; and they made a huge new tunnel which had an outlet many miles away.

It was early in October that they suddenly came out in thousands. Polar Bear says there were at least a million, but that is his favourite big number.

There wer at leest a hundred million.

Anyway, he was still fast asleep at the time, and I was rather drowsy myself; the weather was rather warm for the time of the year and Christmas seemed far away. There were only one or two elves about the place; and of course Paksu and Valkotukka (also fast asleep). The Penguins had all gone away in the spring.

Luckily Goblins cannot help yelling and beating on drums when they mean to fight; so we all woke up in time, and got the gates and doors barred and the windows shuttered. Polar Bear got on the roof and fired rockets into the Goblin hosts as they poured up the long reindeer-drive; but that did not stop them for long. We were soon surrounded.

I have not time to tell you all the story. I had to blow three blasts on the great Horn (Windbeam). It hangs over the fireplace in the hall, and if I have not told you about it before it is because I have not had to blow it for over 4 hundred years: its sound carries as far as the North Wind blows. All the same it was three whole days before help came: snowboys, polar bears, and hundreds and hundreds of elves.

They came up behind the Goblins: and Polar Bear (really awake this time) rushed out with a blazing branch off the fire in each paw. He must have killed dozens of Goblins (he says a million).

But there was a big battle down in the plain near the North Pole in November, in which the Goblins brought hundreds of new companies out of their tunnels. We were driven back to the Cliff, and it was not until Polar Bear and a party of his younger relatives crept out by night, and blew up the entrance to the new tunnels with nearly 100lbs of gunpowder that we got the better of them – for the present.

But bang went all the stuff for making fireworks and crackers (the cracking part) for some years. The North Pole cracked and fell over (for the second time), and we have not yet had time to mend it. Polar Bear is rather a hero (I hope he does not think so himself)

I DO!

But of course he is a very MAGICAL animal really,

N.B.

and Goblins can't do much to him, when he is awake and angry. I have seen their arrows bouncing off him and breaking.

Well, that will give you some idea of events, and you will understand why I have not had time to draw a picture this year – rather a pity, because there have been such exciting things to draw – and why I have not been able to collect the usual things for you, or even the very few that you asked for.

I am told that nearly all the Alison Uttley books have been burnt, and I could not find one of 'Moldy Warp'. I must try and get one for next time. I am sending you a few other books, which I hope you will like. There is not a great deal else, but I send you very much love.

I like to hear about your Bear Bingo, but really I think he is too old and important to hang up stockings! But Polar Bear seems to feel that any kind of bear is a relation. And he said to me, "Leave it to me, old man (that, I am afraid is what he often calls me): I will pack a perfectly beautiful selection for his Poliness (yes, Poliness!)". So I shall try and bring the 'beautiful selection' along: what it is, I don't know!

Very much love from your old friend Father Christmas and Polar Bear

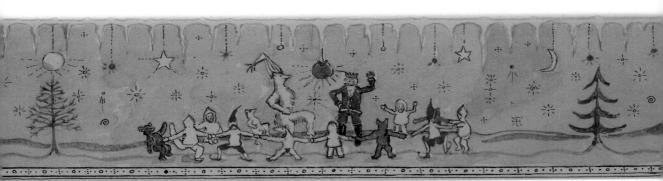

Cliff House, North Pole Christmas Eve 1942

My dear Priscilla,

Polar Bear tells me that he cannot find my letter from you among this year's piles. I hope he has not lost any: he is so untidy. Still I expect you have been very busy this autumn at your new school.

I have had to guess what you would like. I think I know fairly well, and luckily we are still pretty well off for books and things of that sort. But really, you know, I have never seen my stocks so low or my cellars so full of empty places (as Polar Bear says).

I am hoping that I shall be able to replenish them before long; though there is so much waste and smashing going on that it makes me rather sad, and anxious too. Deliveries too are more difficult than ever this year with damaged houses and houseless people and all the dreadful events going on in your countries. Of course it is just as peaceful and merry in my land as ever it was.*

We had our snow early this year and then nice crisp frosty nights to keep it white and firm, and bright starry 'days' (no sun just now of course).

I am giving as big a party tomorrow night as ever I did, polar cubs (Paksu and Valkotukka, of course, among them) and snowboys, and elves. We are having the Tree indoors this year – in the hall at the foot of the great staircase, and I hope Polar Bear does not fall down the stairs and crash into it after it is all decorated and lit up.

I hope you will not mind my bringing this little letter along with your things tonight: I am short of messengers, as some have great trouble in finding people and have been away for days. Just now I caught Polar Bear in my pantry, and I am sure he had been to a cupboard. I do not know why.

Christmas Eve

My Lear Priscilla,

T. B. tells, me that he cannot find any letter from you among This year's viles. Thopse he has not lost any thers Oso untidy . Still Jensey you have been very busy this autumn at your new sen cook I have had To guess what you would like I think I know fairly well and litcking we are stall pretty well off forbooks and things of that sont. But really you know, I have newer seen my stocks solow or my cellars so full of entisty places Cas 15 to sous although he is not an Trish bear am hoping that I shall be able to reptenish than before long; though there is somnial waste and smashing Joing on that it makes me rather sad and anyoines too Deliveries too are more difficult than ever this year with damaged houses and houseless people and all the dreadful Events going on in your countries. Of course it just as beaceful and meny in my land as wer it wast We had our snow early this year and then nice crisp Frosty nights to keep it white and firm and bright stamidays (no sun fust now (1) Tofconse among them? and snowbays, and thes We are having the Tree moons this year win the hall at the foot of the great staircase, and I hope 1. 3 does not fatt down the stairs and crash into it after it is all decorated and I hope you will not mind my bringing this little letter along with Thomas to mant: Jam short of inessencers, as some have great trouble in Finding people and have been away for days. Tust now Jeaught B. Bin my panery, and Jam sure he had been to a cupboard. Jamest Know thy. He has wrapped up a mysterious small parcel which he wants me to bring to You - well not exactly to you (he said) : She has got a bear too, as you ought to remember." Welling dear here is very much love from father Phristmas oncemore, and very good of wishes for 1943

Ho battles at all this year. Quiet as quiet. I think the Goblins were really enished that sime. Windbeam is hanging over the mantlepiece and is quite dusty again, Jam alad to say. Dut P.B. has spent lots of time this year making-fresh guing awder-justin case of trouble. He said wouldn't that grubby pt

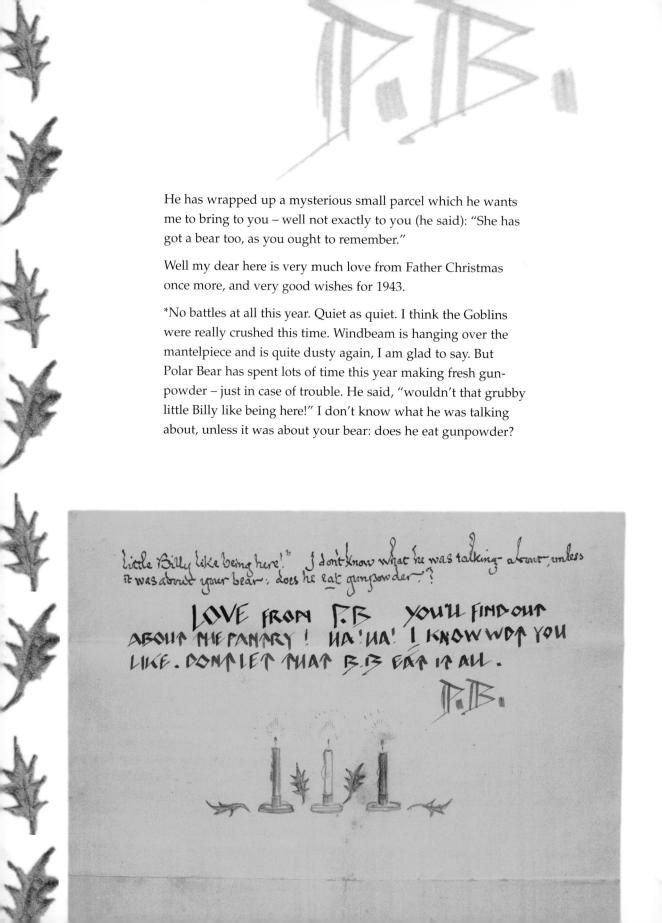

You'll find out about the pantry! Ha! Ha! I know wot you like. Don't let that Billy Bear eat it all!

Love from Polar Bear.

Messige to Billy Bear from Polar Bear Sorry I could not send you a really good bomb. All our powder has gone up in a big bang. You would have seen wot a really good exploashion is like. If yould been there.

1943.

Cliff House, North Pole, Christmas 1943

My dear Priscilla

A very happy Christmas! I suppose you will be hanging up your stocking just once more: I hope so for I have still a few little things for you. After this I shall have to say "goodbye", more or less: I mean, I shall not forget you. We always keep the old numbers of our old friends, and their letters; and later on we hope to come back when they are grown up and have houses of their own and children.

My messengers tell me that people call it "grim" this year. I think they mean miserable: and so it is, I fear, in very many places where I was specially fond of going; but I am very glad to hear that you are still not really miserable. Don't be! I am still very much alive, and shall come back again soon, as merry as ever. There has been no damage in my country; and though my stocks are running rather low I hope soon to put that right.

Polar Bear - too "tired" to write himself (so he says) -

I am, reely

sends a special message to you: love and a hug! He says: do ask if she still has a bear called Silly Billy, or something like that; or is he worn out?

Give my love to the others: John and Michael and Christopher – and of course to all your pets that you used to tell me about. Polar Bear and all the Cubs are very well. They have really been very good this year and have hardly had time to get into any mischief.

I hope you will find most of the things that you wanted and I am very sorry that I have no 'Cats' Tongues' left. But I have sent nearly all the books you asked for. I hope your stocking will seem full!

Very much love from your old friend, Father Christmas.

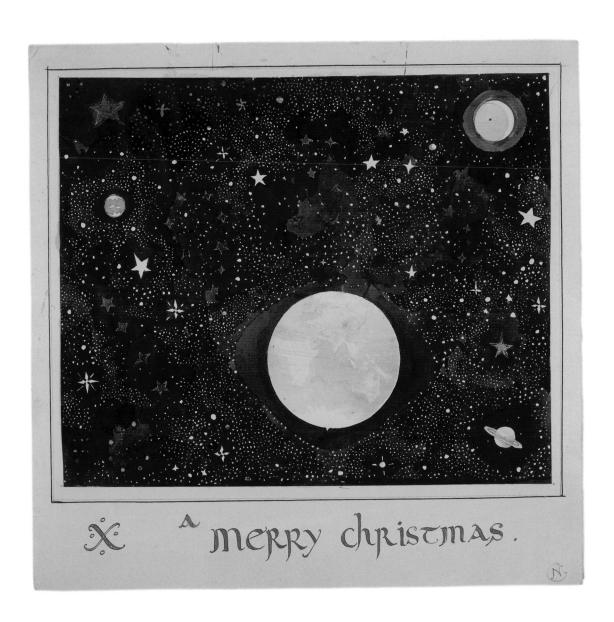

WORKS BY J. R. R. TOLKIEN

The Hobbit
The Lord of the Rings
Leaf by Niggle
On Fairy Stories
The Homecoming of Beorhtnoth
Farmer Giles of Ham
The Adventures of Tom Bombadil
Smith of Wootton Major
The Road Goes Ever On (with Donald Swann)

Works published posthumously

The Silmarillion
The Father Christmas Letters
Sir Gawain, Pearl and Sir Orfeo
Pictures by J.R.R. Tolkien
Unfinished Tales
The Letters of J.R.R. Tolkien
Mr Bliss
The Monsters and the Critics & Other Essays
Finn and Hengest
Roverandom

THE HISTORY OF MIDDLE-EARTH by Christopher Tolkien

I The Book of Lost Tales, Part One
II The Book of Lost Tales, Part Two
III The Lays of Beleriand
IV The Shaping of Middle-earth
V The Lost Road and Other Writings
VI The Return of the Shadow
VII The Treason of Isengard
VIII The War of the Ring
IX Sauron Defeated
X Morgoth's Ring
XI The War of the Jewels
XII The Peoples of Middle-earth